Dear Diary.

I admit it: writing in a journal can be a bit dull. (No offense.) You may not realize this, diary, but I spend more time staring at the blank page wondering what to write than I spend actually writing in you. So, I'm doing it differently this time. This time, I'm turning my journaling time into journeying time!

In these pages, I'll follow paths that lead me to discoveries I never saw coming and to memories I may have forgotten. It's like a "choose your own adventure" novel, except the adventure is my own life. If I'm in a reflective mood, for example, I'll go on a self-discovery journey. All I have to do is begin on the designated page, complete the self-discovery prompt, and skip ahead to next prompt until the journey is fulfilled. The journey ends with retrospectives that give me a chance to understand the big picture behind the journaling process.

This new journal will be so much more than a record of my daily thoughts—this new journal will make me a more thoughtful, more proactive person. And it will be more fun to write!

Sorry, blank page, there's nothing blank about me.

Choose Your Journey

Destination Journey	
Finding your life's purpose or true calling	Start on page 6
Humanitarian Journey	
Make a difference in the world	Start on page 6
Overcomer's Journey	
Conquering your fears	Start on page 7
Chaotic Resolve Journey	
Achieving inner peace	Start on page 7
Achievement Journey	
Creating new goals	Start on page 8
Self-discovery Journey	
Exploring your true creative passions	Start on page 8
Writing a New Chapter Journey	
Learning from past mistakes	Start on page 9
Mending Fences Journey	
Righting my wrongs	Start on page 9
Self-improvement Journey	
Loving yourself through acceptance	Start on page 10
Spiritual Journey	
Exploring my beliefs	Start on page 10

thought you if it was a c	u wanted to be when yo rcus clown. <i>Turn to page 1</i> .	your childhood. Make a list of all the things you were younger and why. List everything, e ^o
Humanita	rian Journey: What ca	auses, charities or organizations are close to
Humanita your heart a	rian Journey: What ca and why? Turn to page 11	auses, charities or organizations are close to
Humanita your heart a	rian Journey: What ca and why? Turn to page 11	auses, charities or organizations are close to
Humanita your heart a	rian Journey: What ca and why? Turn to page 11	auses, charities or organizations are close to
Humanita your heart a	rian Journey: What ca and why? Turn to page 11	auses, charities or organizations are close to
Humanita your heart a	rian Journey: What ca and why? Turn to page 11	auses, charities or organizations are close to
Humanita your heart a	rian Journey: What ca and why? Turn to page 11	auses, charities or organizations are close to
Humanita your heart a	rian Journey: What ca	auses, charities or organizations are close to
Humanita your heart a	rian Journey: What ca	auses, charities or organizations are close to
Humanita your heart a	rian Journey: What ca	auses, charities or organizations are close to
Humanita your heart a	rian Journey: What ca	auses, charities or organizations are close to
Humanita your heart	rian Journey: What ca	auses, charities or organizations are close to
Humanita your heart	rian Journey: What ca	auses, charities or organizations are close to
Humanita your heart	rian Journey: What ca	auses, charities or organizations are close to
Humanita your heart	rian Journey: What ca	auses, charities or organizations are close to
Humanita your heart	rian Journey: What ca	auses, charities or organizations are close to
Humanita your heart	rian Journey: What ca	auses, charities or organizations are close to
Humanita your heart	rian Journey: What ca	auses, charities or organizations are close to
Humanita your heart	rian Journey: What ca	auses, charities or organizations are close to
Humanita your heart	rian Journey: What ca	auses, charities or organizations are close to

Overcome hem. Wha	t effect do th	ley have on vo					
		,	, , , , , , , , , , , , , , , , , , , ,				
	-						
Chaotic R	esolve Jour	ney: Write ab	out things th	at are makir	ng your life	feel	
Chaotic R haotic and	esolve Jour I how it got t	ney: Write ab his way. <i>Turn to</i>	out things th	at are makir	ng your life	feel	
Chaotic R haotic and	esolve Jour I how it got t	ney: Write ab his way. <i>Turn to</i>	out things th	at are makir	ng your life	feel	
Chaotic R haotic and	esolve Jour I how it got t	ney: Write ab his way. <i>Turn to</i>	out things th	at are makir	ng your life	feel	
Chaotic R haotic and	esolve Jour I how it got t	ney: Write ab his way. <i>Turn to</i>	out things th	at are makir	ng your life	feel	
Chaotic R haotic and	esolve Jour I how it got t	ney: Write ab his way. <i>Turn to</i>	out things th	at are makir	ng your life	feel	
Chaotic R haotic and	esolve Jour. I how it got t	ney: Write ab his way. <i>Turn to</i>	out things th	at are makir	ng your life	feel	
Chaotic R haotic and	esolve Jour I how it got t	ney: Write ab his way. <i>Turn to</i>	out things th	at are makir	9	feel	
Chaotic R haotic and	esolve Jour. I how it got t	ney: Write ab	out things th	at are makir	ng your life	feel	
Chaotic R	esolve Jour I how it got t	ney: Write ab	out things th	at are makir	9	feel	
Chaotic R haotic and	esolve Jour I how it got t	ney: Write ab	out things th	at are makir	9	feel	
Chaotic R	esolve Jour I how it got t	ney: Write ab	out things th	at are makir	9	feel	
Chaotic R haotic and	esolve Jour I how it got t	ney: Write ab	out things th	at are makir	9	feel	
Chaotic R	esolve Jour I how it got t	ney: Write ab	out things th	at are makir	9	feel	

Self-discovery Jo	urney: Write a	about what y	ou love to do	in your spare	time.
Self-discovery Jo Turn to page 13	urney: Write a	about what y	ou love to do	in your spare	time.
Self-discovery Jo Turn to page 13	urney: Write a	about what y	ou love to do	in your spare	time.
Self-discovery Jo Turn to page 13	urney: Write a	about what y	ou love to do	in your spare	time.
Self-discovery Jo Turn to page 13	urney: Write a	about what y	ou love to do	in your spare	time.
Self-discovery Jo Turn to page 13	urney: Write a	about what y	ou love to do	in your spare	time.
Self-discovery Jo Turn to page 13	urney: Write a	about what y	ou love to do	in your spare	time.
Self-discovery Jo Turn to page 13	urney: Write a	about what y	ou love to do	in your spare	time.
Self-discovery Jo Turn to page 13	urney: Write a	about what y	ou love to do	in your spare	time.
Self-discovery Jo Turn to page 13	urney: Write a	about what y	ou love to do	in your spare	time.
Self-discovery Jo Turn to page 13	urney: Write a	about what y	ou love to do	in your spare	time.
Self-discovery Jo Turn to page 13	urney: Write a	about what y	ou love to do	in your spare	time.
Self-discovery Jo Turn to page 13	urney: Write a	about what yo	ou love to do	in your spare	time.
Self-discovery Jo Turn to page 13	urney: Write a	about what yo	ou love to do	in your spare	time.
Self-discovery Jo Turn to page 13	urney: Write a	about what yo	ou love to do	in your spare	time.
Self-discovery Jo Turn to page 13	urney: Write a	about what y	ou love to do	in your spare	time.
Self-discovery Jo Turn to page 13	urney: Write a	about what y	ou love to do	in your spare	time.
Self-discovery Jo Turn to page 13	urney: Write a	about what y	ou love to do	in your spare	time.
Self-discovery Jo Turn to page 13	urney: Write a	about what y	ou love to do	in your spare	time.
Self-discovery Jo Turn to page 13	urney: Write a	about what y	ou love to do	in your spare	time.
Self-discovery Jo Turn to page 13	urney: Write a	about what y	ou love to do	in your spare	time.

r rid yourse	nting you or weighing you down? How can you make peace with thiself of these ghosts? <i>Turn to page 14</i>)
Mending F Explain how	Sences Journey: Do you hurt others to feel better about yourself? and why you think you do this? <i>Turn to page 14</i>	
Mending F Explain how	Sences Journey: Do you hurt others to feel better about yourself? and why you think you do this? <i>Turn to page 14</i>	
Mending F Explain how	Pences Journey: Do you hurt others to feel better about yourself? and why you think you do this? <i>Turn to page 14</i>	
Mending F Explain how	Pences Journey: Do you hurt others to feel better about yourself? and why you think you do this? <i>Turn to page 14</i>	
Mending F Explain how	Sences Journey: Do you hurt others to feel better about yourself? and why you think you do this? <i>Turn to page 14</i>	
Mending F Explain how	Sences Journey: Do you hurt others to feel better about yourself? and why you think you do this? <i>Turn to page 14</i>	
Mending F Explain how	Sences Journey: Do you hurt others to feel better about yourself? and why you think you do this? <i>Turn to page 14</i>	
Mending F Explain how	Sences Journey: Do you hurt others to feel better about yourself? and why you think you do this? <i>Turn to page 14</i>	
Mending F Explain how	Pences Journey: Do you hurt others to feel better about yourself? and why you think you do this? Turn to page 14	
Mending F Explain how	Pences Journey: Do you hurt others to feel better about yourself? and why you think you do this? Turn to page 14	
Mending F Explain how	Pences Journey: Do you hurt others to feel better about yourself? and why you think you do this? Turn to page 14	
Mending F Explain how	Pences Journey: Do you hurt others to feel better about yourself? and why you think you do this? Turn to page 14	

Spiritual Jou	urney: Write abou	ut your currer	nt beliefs and	d what they	mean to you
Spiritual Jou Do you practi	urney: Write abou	ut your currer ligion? <i>Turn to</i>	nt beliefs and	d what they	mean to you
Spiritual Jou Do you practi	urney: Write abou	ut your currer ligion? <i>Turn to</i>	nt beliefs and	d what they	mean to you
Spiritual Jou Do you practi	urney: Write abou	ut your currer ligion? <i>Turn to</i>	nt beliefs and page 15	d what they	mean to you
Spiritual Jou Do you practi	urney: Write abou	ut your currer eligion? <i>Turn to</i>	nt beliefs and page 15	d what they	mean to you
Spiritual Jou Do you practi	urney: Write abou	ut your currer eligion? <i>Turn to</i>	nt beliefs and page 15	d what they	mean to you
Spiritual Jou Do you practi	urney: Write abouce any form of re	ut your currer eligion? <i>Turn to</i>	nt beliefs and page 15	d what they	mean to you
Spiritual Jou Do you practi	urney: Write abouce any form of re	ut your currer eligion? <i>Turn to</i>	nt beliefs and page 15	d what they	mean to you
Spiritual Jou Do you practi	urney: Write abouce any form of re	ut your currer ligion? <i>Turn to</i>	nt beliefs and page 15	d what they	mean to you
Spiritual Jou Do you practi	urney: Write abou	ut your currer Higion? <i>Turn to</i>	nt beliefs and page 15	d what they	mean to you
Spiritual Jou Do you practi	urney: Write abou	ut your currer	nt beliefs and page 15	d what they	mean to you
Spiritual Jou Do you practi	urney: Write abou	ut your currer	nt beliefs and page 15	d what they	mean to you
Spiritual Jou Do you practi	urney: Write abou	ut your currer	nt beliefs and	d what they	mean to you
Spiritual Jou Do you practi	urney: Write abou	ut your currer	nt beliefs and	d what they	mean to you
Spiritual Jou Do you practi	urney: Write about	ut your currer	nt beliefs and	d what they	mean to you
Spiritual Jou Do you practi	urney: Write about ce any form of re	ut your currer	nt beliefs and	d what they	mean to you
Spiritual Jou Do you practi	urney: Write about ce any form of re	ut your currer	nt beliefs and	d what they	mean to you
Spiritual Jou Do you practi	arney: Write about ce any form of re	ut your currer eligion? <i>Turn to</i>	nt beliefs and	d what they	mean to you
Spiritual Jou Do you practi	arney: Write about ce any form of re	ut your currer	nt beliefs and	d what they	mean to you

Iumanitariar hy you want t	Journey: Make o volunteer there	e a list of all the	e places you w	ant to voluntee	r and
lumanitariar hy you want t	n Journey: Make o volunteer there	e a list of all the	places you w	ant to voluntee	r and
Iumanitariar hy you want t	n Journey: Make o volunteer there	e a list of all the	places you w	ant to voluntee	r and
Iumanitariar hy you want t	n Journey: Make o volunteer there	a list of all the	places you w	ant to voluntee	r and
Iumanitariar hy you want t	n Journey: Make o volunteer there	e a list of all the	Places you w	ant to voluntee	r and
Iumanitariar hy you want t	n Journey: Make o volunteer there	e a list of all the	places you w	ant to voluntee	r and
Iumanitariar hy you want t	n Journey: Make o volunteer there	e a list of all the	places you w	ant to voluntee	r and
Iumanitariar hy you want t	n Journey: Make o volunteer there	e a list of all the	Places you w	ant to voluntee	r and
Iumanitariar	Journey: Make	e a list of all the	places you w	ant to voluntee	r and
Iumanitariar hy you want t	n Journey: Make o volunteer there	e a list of all the	Places you w	ant to voluntee	r and
Iumanitariar	n Journey: Make o volunteer there	e a list of all the	places you w	ant to voluntee	r and
Jumanitariar Thy you want to	Dourney: Make to volunteer there	e a list of all the	places you w	ant to voluntee	r and

t makes it negative. II or friend. <i>Turn to page 17</i>	nis can be any re	elationsnip: work, family.
	e Journey: Write abo t makes it negative. Tl or friend. <i>Turn to page 17</i>	e Journey: Write about the most negative. This can be any reported. <i>Turn to page 17</i>

	Journey: What are your "current goals?" Write about your current how you're pursuing them. <i>Turn to page 18</i>
elf-discovery	Journey If you had more time, how would you spond it? 7
elf-discovery	Journey: If you had more time, how would you spend it? Turn to
elf-discovery	Journey: If you had more time, how would you spend it? Turn to
elf-discovery	Journey: If you had more time, how would you spend it? Turn to
elf-discovery	Journey: If you had more time, how would you spend it? Turn to
elf-discovery	Journey: If you had more time, how would you spend it? Turn to
elf-discovery	Journey: If you had more time, how would you spend it? Turn to
elf-discovery	Journey: If you had more time, how would you spend it? Turn to
elf-discovery	Journey: If you had more time, how would you spend it? Turn to
elf-discovery	Journey: If you had more time, how would you spend it? Turn to
elf-discovery	Journey: If you had more time, how would you spend it? Turn to
elf-discovery	Journey: If you had more time, how would you spend it? Turn to
elf-discovery	Journey: If you had more time, how would you spend it? Turn to
elf-discovery	Journey: If you had more time, how would you spend it? Turn to
elf-discovery	Journey: If you had more time, how would you spend it? Turn to

lending Fences Journey: Do you admit when you're wrong in disagreements by you take responsibility for your role in the argument? Describe a fight that appened you wished you'd handled differently. <i>Turn to page 19</i>

elieving in yours	ent Journey: Belie self? What can you	ı do to believe i	n vourself more	? Turn to hage 20
0 , ,			, Jourson More	I urn to page 20
				e e
		D.		
		· ·		
piritual Journe urn to page 20	ey: What are the b	asic principles c	of your belief sy	stem/religion?
piritual Journe urn to page 20	ey: What are the b	asic principles d	of your belief sy	stem/religion?
piritual Journe urn to page 20	ey: What are the b	asic principles d	of your belief sy	stem/religion?
piritual Journe urn to page 20	ey: What are the b	asic principles d	of your belief sy	stem/religion?
piritual Journe urn to page 20	ey: What are the b	asic principles d	of your belief sy	stem/religion?
piritual Journe urn to page 20	ey: What are the b	asic principles d	of your belief sy	stem/religion?
piritual Journe urn to page 20	ey: What are the b	asic principles d	of your belief sy	stem/religion?
piritual Journe urn to page 20	ey: What are the b	asic principles d	of your belief sy	stem/religion?
piritual Journe	ey: What are the b	asic principles d	of your belief sy	stem/religion?
piritual Journe	ey: What are the b	asic principles d	of your belief sy	stem/religion?
piritual Journe	ey: What are the b	asic principles o	of your belief sy	stem/religion?
piritual Journe	ey: What are the b	asic principles o	of your belief sy	stem/religion?

Destination Journey: Not) and how their work in	
Humanitarian Journey	y: Spend the day volunteering somewhere and write
Humanitarian Journey about the experience. Tu	y: Spend the day volunteering somewhere and write urn to page 21
Humanitarian Journey about the experience. Tu	y: Spend the day volunteering somewhere and write urn to page 21
Humanitarian Journey about the experience. Tu	y: Spend the day volunteering somewhere and write urn to page 21
Humanitarian Journey about the experience. Tu	y: Spend the day volunteering somewhere and write urn to page 21
Humanitarian Journey about the experience. Tu	y: Spend the day volunteering somewhere and write urn to page 21
Humanitarian Journey about the experience. Tu	y: Spend the day volunteering somewhere and write urn to page 21
Humanitarian Journey about the experience. Tu	y: Spend the day volunteering somewhere and write urn to page 21
Humanitarian Journey about the experience. Tu	y: Spend the day volunteering somewhere and write urn to page 21
Humanitarian Journey about the experience. Tu	y: Spend the day volunteering somewhere and write urn to page 21
Humanitarian Journey about the experience. Tu	y: Spend the day volunteering somewhere and write urn to page 21
Humanitarian Journey about the experience. Tu	y: Spend the day volunteering somewhere and write urn to page 21
Humanitarian Journey about the experience. Tu	y: Spend the day volunteering somewhere and write urn to page 21
Humanitarian Journey about the experience. Tu	y: Spend the day volunteering somewhere and write urn to page 21
Humanitarian Journey about the experience. Tu	y: Spend the day volunteering somewhere and write urn to page 21
Humanitarian Journey about the experience. Tu	y: Spend the day volunteering somewhere and write urn to page 21
Humanitarian Journey about the experience. Tu	y: Spend the day volunteering somewhere and write arn to page 21
Humanitarian Journey about the experience. Tu	y: Spend the day volunteering somewhere and write arn to page 21
Humanitarian Journey about the experience. Tu	y: Spend the day volunteering somewhere and write urn to page 21

bage 22		
Chaoti vhy you	c Resolve Journey: Now think about the last question and write about u still have this relationship in your life. Can this relationship be repaired? If	
/hy yol	c Resolve Journey: Now think about the last question and write about a still have this relationship in your life. Can this relationship be repaired? If y are you still holding on? Turn to page 22	
/hy yol	a still have this relationship in your life. Can this relationship be repaired? If	
vhy you	a still have this relationship in your life. Can this relationship be repaired? If	
/hy yol	a still have this relationship in your life. Can this relationship be repaired? If	
/hy yol	a still have this relationship in your life. Can this relationship be repaired? If	
/hy yol	a still have this relationship in your life. Can this relationship be repaired? If	
/hy yol	a still have this relationship in your life. Can this relationship be repaired? If	
/hy yol	a still have this relationship in your life. Can this relationship be repaired? If	
/hy yol	a still have this relationship in your life. Can this relationship be repaired? If	
/hy yol	a still have this relationship in your life. Can this relationship be repaired? If	
/hy yol	a still have this relationship in your life. Can this relationship be repaired? If	
/hy yol	a still have this relationship in your life. Can this relationship be repaired? If	
/hy yol	a still have this relationship in your life. Can this relationship be repaired? If	
/hy yol	a still have this relationship in your life. Can this relationship be repaired? If	
vhy you	a still have this relationship in your life. Can this relationship be repaired? If	
vhy you	a still have this relationship in your life. Can this relationship be repaired? If	
vhy you	a still have this relationship in your life. Can this relationship be repaired? If	
vhy you	a still have this relationship in your life. Can this relationship be repaired? If	
vhy you	a still have this relationship in your life. Can this relationship be repaired? If	
vhy you	a still have this relationship in your life. Can this relationship be repaired? If	
vhy you	a still have this relationship in your life. Can this relationship be repaired? If	
vhy you	a still have this relationship in your life. Can this relationship be repaired? If	

Self-discove	ery Journey:	What is one	thing you've a	always want	ted to do but
Self-discove haven't yet tr	ery Journey: ied? Turn to page	What is one	thing you've a	always want	ted to do but
Self-discove haven't yet tr	ery Journey: ied? <i>Turn to pag</i>	What is one	thing you've a	always want	ted to do but
Self-discove haven't yet tr	ery Journey: `ied? Turn to pag	What is one	thing you've a	always want	ted to do but
Self-discove haven't yet tr	ery Journey: ied? <i>Turn to pag</i>	What is one	thing you've a	always want	ted to do but
Self-discove haven't yet tr	ery Journey: \ied? Turn to pag	What is one	thing you've a	always want	ted to do but
Self-discove haven't yet tr	ery Journey: \ied? Turn to pag	What is one	thing you've a	always want	ted to do but
Self-discove haven't yet tr	ery Journey: ied? Turn to pag	What is one	thing you've a	always want	ted to do but
Self-discove haven't yet tr	ery Journey: ied? Turn to pag	What is one	thing you've a	always want	ted to do but
Self-discove haven't yet tr	ery Journey: \ied? Turn to pag	What is one	thing you've a	always want	ted to do but
Self-discove haven't yet tr	ery Journey: \ied? Turn to pag	What is one	thing you've a	always want	ted to do but
Self-discove haven't yet tr	ery Journey: \ied? Turn to pag	What is one	thing you've a	always want	ted to do but
Self-discove haven't yet tr	ery Journey: ied? Turn to pag	What is one	thing you've a	always want	ted to do but
Self-discove haven't yet tr	ery Journey: ied? Turn to pag	What is one	thing you've a	always want	ted to do but
Self-discove haven't yet tr	ery Journey: Yied? Turn to pag	What is one	thing you've a	always want	ted to do but
Self-discove haven't yet tri	ery Journey: \ied? Turn to pag	What is one	thing you've a	always want	ted to do but
Self-discove haven't yet tr	ery Journey: \ied? Turn to pag	What is one	thing you've a	always want	ted to do but

Writing a New Chapter Journey: Look for ways to learn lessons each day. Good days or bad days there is something to gain from each day. What did you learn today? <i>Turn to page 24</i>	
Mending Fences Journey: Do you participate in gossip or talk about people behind their back? Has this happened to you, if so how did it make you feel?	
Turn to page 24	

sett-ir	a list and figure out how you can take healthy steps to work towards your mprovement goals. <i>Turn to page 25</i>
	3
Spiri	tual Journey: Do you believe in God? Write about your God and what he
Spiri mean	tual Journey: Do you believe in God? Write about your God and what he s in your life. <i>Turn to page 25</i>
Spiri mean	tual Journey: Do you believe in God? Write about your God and what he s in your life. <i>Turn to page 25</i>
Spiri mean	tual Journey: Do you believe in God? Write about your God and what he s in your life. <i>Turn to page 25</i>
Spiri mean	tual Journey: Do you believe in God? Write about your God and what he s in your life. <i>Turn to page 25</i>
Spiri mean	tual Journey: Do you believe in God? Write about your God and what he s in your life. <i>Turn to page 25</i>
Spiri mean	tual Journey: Do you believe in God? Write about your God and what he s in your life. <i>Turn to page 25</i>
Spiri mean	tual Journey: Do you believe in God? Write about your God and what he s in your life. <i>Turn to page 25</i>
Spiri mean	tual Journey: Do you believe in God? Write about your God and what he s in your life. <i>Turn to page 25</i>
Spiri mean	tual Journey: Do you believe in God? Write about your God and what he s in your life. Turn to page 25
Spiri mean	tual Journey: Do you believe in God? Write about your God and what he s in your life. Turn to page 25
Spiri mean	tual Journey: Do you believe in God? Write about your God and what he s in your life. Turn to page 25
Spiri mean	tual Journey: Do you believe in God? Write about your God and what he s in your life. Turn to page 25
Spiri	tual Journey: Do you believe in God? Write about your God and what he s in your life. Turn to page 25
Spiri	tual Journey: Do you believe in God? Write about your God and what he s in your life. Turn to page 25
Spiri	tual Journey: Do you believe in God? Write about your God and what he s in your life. Turn to page 25
Spiri	tual Journey: Do you believe in God? Write about your God and what he s in your life. Turn to page 25
Spiri	tual Journey: Do you believe in God? Write about your God and what he s in your life. Turn to page 25
Spiri	tual Journey: Do you believe in God? Write about your God and what he s in your life. Turn to page 25
Spiri	tual Journey: Do you believe in God? Write about your God and what he s in your life. Turn to page 25

and con list of your work. Then ask your current boss or supervisor to write a list of your strongest qualities and areas that need improvement. <i>Turn to page 26</i>	
Humanitarian Journey: Go to a children's hospital and play games with the kids, have story time or make them laugh. Document the emotional day here in the journal. <i>Turn to page 26</i>	

Turn to page 2					
Chaotic R	esolve Journey	y: Write your	very own de	finition of pea	ice. Not what
Chaotic R the dictiona	esolve Journey ary says but how	y: Write your v peace woul	very own de ld be describ	finition of pea	nce. Not what e. Turn to page 2
Chaotic R the dictiona	Lesolve Journey ary says but how	y: Write your v peace woul	very own dei ld be describ	finition of pea	ice. Not what
Chaotic R the dictiona	esolve Journey ary says but how	y: Write your v peace woul	very own dei ld be describ	finition of pea	ace. Not what
Chaotic R the dictiona	esolve Journey ary says but how	y: Write your v peace woul	very own dei ld be describ	finition of pea ed in your life	ace. Not what
Chaotic R the dictiona	esolve Journey ary says but how	y: Write your v peace woul	very own dei ld be describ	finition of pea ed in your life	ace. Not what
Chaotic R the dictiona	esolve Journey ary says but how	y: Write your v peace woul	very own dei ld be describ	finition of pea ed in your life	ace. Not what
Chaotic R the dictiona	esolve Journey ary says but how	y: Write your v peace woul	very own dei ld be describ	finition of pea	ace. Not what
Chaotic R the dictiona	esolve Journey ary says but how	y: Write your v peace woul	very own de ld be describ	finition of pea	ace. Not what
Chaotic R the dictiona	esolve Journey	y: Write your v peace woul	very own de ld be describ	finition of pea	ace. Not what
Chaotic R the dictiona	esolve Journey ary says but how	y: Write your v peace woul	very own de ld be describ	finition of pea	ace. Not what
Chaotic R the dictiona	esolve Journey ary says but how	y: Write your v peace woul	very own de ld be describ	finition of pea	ace. Not what
Chaotic R the dictiona	desolve Journey ary says but how	y: Write your v peace woul	very own de ld be describ	finition of pea	ace. Not what
Chaotic R the dictiona	desolve Journey ary says but how	y: Write your v peace woul	very own de ld be describ	finition of pea	ace. Not what
Chaotic R the dictiona	desolve Journey ary says but how	y: Write your v peace woul	very own de ld be describ	finition of pea	ace. Not what
Chaotic R the dictiona	desolve Journey ary says but how	y: Write your v peace woul	very own de ld be describ	finition of pea	ace. Not what
Chaotic R the dictiona	desolve Journey ary says but how	y: Write your v peace woul	very own de ld be describ	finition of pea	ace. Not what
Chaotic R the dictiona	desolve Journey ary says but how	y: Write your v peace woul	very own de ld be describ	finition of pea	ace. Not what
Chaotic R	desolve Journey ary says but how	y: Write your v peace woul	very own de ld be describ	finition of pea	ace. Not what

hy have they	t Journey: How changed? Turn	to page 28	oats change	a over the tas	or 2 Aeatz aug
				•	
elf-discover ant to try? Tu	ry Journey: Tap urn to page 28	into your cre	eative side. V	Vhat new hol	obies do you
		,			

	to page 29				
Mending Fer	nces Journey: H	ave you ever s	tarted a rumor a	about someone?	Did
Mending Fer you apologize	nces Journey: H to this person? V	ave you ever s Why did you st	tarted a rumor a art the rumor? <i>T</i>	about someone? Furn to page 29	Did
Mending Fer you apologize	nces Journey: Ha to this person? V	ave you ever s Why did you st	tarted a rumor a art the rumor? T	about someone? Furn to page 29	Did
Mending Fer you apologize	nces Journey: Ha to this person? V	ave you ever s Why did you st	tarted a rumor a art the rumor? T	about someone? Furn to page 29	Did
Mending Fer you apologize	nces Journey: H to this person? V	ave you ever s Why did you st	tarted a rumor a art the rumor? T	about someone? Furn to page 29	Did
Mending Fer you apologize	nces Journey: H to this person? V	ave you ever s Why did you st	tarted a rumor a	about someone?	Did
Mending Fer	nces Journey: Ha to this person? V	ave you ever s Why did you st	tarted a rumor a art the rumor? T	about someone?	Did
Mending Fer	nces Journey: H. to this person? V	ave you ever s Why did you st	tarted a rumor a	about someone?	Did
Mending Fer	nces Journey: H to this person? V	ave you ever s Why did you st	tarted a rumor a art the rumor? T	about someone?	Did
Mending Fer	nces Journey: H	ave you ever s Why did you st	tarted a rumor a	about someone?	Did
Mending Fer	nces Journey: H	ave you ever s Why did you st	tarted a rumor a	about someone?	Did

piritual Journey show each othe	T: Do you appreciate other people's beliefs? We rrespect concerning those beliefs? Turn to page	/hy is it important 30
piritual Journey show each othe	r: Do you appreciate other people's beliefs? W r respect concerning those beliefs? <i>Turn to page</i>	/hy is it important 30
piritual Journey show each othe	r: Do you appreciate other people's beliefs? W r respect concerning those beliefs? <i>Turn to page</i>	/hy is it important 30
piritual Journey show each othe	r: Do you appreciate other people's beliefs? W r respect concerning those beliefs? <i>Turn to page</i>	/hy is it important 30
piritual Journey show each othe	r: Do you appreciate other people's beliefs? Wr respect concerning those beliefs? Turn to page	/hy is it important 30
piritual Journey show each othe	r: Do you appreciate other people's beliefs? W r respect concerning those beliefs? <i>Turn to page</i>	/hy is it important 30
piritual Journey show each othe	r: Do you appreciate other people's beliefs? W r respect concerning those beliefs? <i>Turn to page</i>	/hy is it important 30
piritual Journey show each othe	r: Do you appreciate other people's beliefs? We respect concerning those beliefs? Turn to page	/hy is it important 30
piritual Journey show each othe	r: Do you appreciate other people's beliefs? W r respect concerning those beliefs? <i>Turn to page</i>	/hy is it important 30
piritual Journey	r: Do you appreciate other people's beliefs? W r respect concerning those beliefs? Turn to page	/hy is it important 30
piritual Journey	r: Do you appreciate other people's beliefs? W r respect concerning those beliefs? Turn to page	/hy is it important 30
piritual Journey	r: Do you appreciate other people's beliefs? W r respect concerning those beliefs? Turn to page	/hy is it important 30
piritual Journey	r: Do you appreciate other people's beliefs? W r respect concerning those beliefs? Turn to page	/hy is it important 30
piritual Journey	r: Do you appreciate other people's beliefs? We respect concerning those beliefs? Turn to page	/hy is it important 30
piritual Journey	r: Do you appreciate other people's beliefs? We respect concerning those beliefs? Turn to page	/hy is it important 30

like you na	ve fulfilled your purpose. Turn to	be how that work would make you fee o page 31
Humanit	arian Journey: Think about ho	ow your skills can best serve the world make a difference. <i>Turn to page 31</i>
Humanit and write a	arian Journey: Think about ho a summary about how you can	w your skills can best serve the world make a difference. <i>Turn to page 31</i>
Humanit and write a	arian Journey: Think about ho a summary about how you can	ow your skills can best serve the world make a difference. <i>Turn to page 31</i>
Humanit and write a	arian Journey: Think about ho a summary about how you can	w your skills can best serve the world make a difference. <i>Turn to page 31</i>
Humanit and write a	arian Journey: Think about ho a summary about how you can	ow your skills can best serve the world make a difference. <i>Turn to page 31</i>
Humanit and write a	arian Journey: Think about ho a summary about how you can	ow your skills can best serve the world make a difference. <i>Turn to page 31</i>
Humanit and write a	arian Journey: Think about ho a summary about how you can	ow your skills can best serve the world make a difference. <i>Turn to page 31</i>
Humanit and write a	arian Journey: Think about ho a summary about how you can	ow your skills can best serve the world make a difference. <i>Turn to page 31</i>
Humanit and write a	arian Journey: Think about ho	ow your skills can best serve the world make a difference. <i>Turn to page 31</i>
Humanit and write a	arian Journey: Think about ho	ow your skills can best serve the world make a difference. <i>Turn to page 31</i>
Humanit and write a	arian Journey: Think about ho	ow your skills can best serve the world make a difference. <i>Turn to page 31</i>
Humanit and write a	arian Journey: Think about ho	ow your skills can best serve the world make a difference. <i>Turn to page 31</i>
Humanit and write a	arian Journey: Think about ho	ow your skills can best serve the world make a difference. Turn to page 31

Overcome appened						
Chaotic R	esolve Journ	ey: Would yo	u describe y	yourself as a	lover or figh	ter?
Chaotic Rollow do you	esolve Journ I feel about th	ey: Would yo	ou describe y	yourself as a	lover or figh	ter?
Chaotic Rollow do you	esolve Journ I feel about th	ey: Would yo	u describe y	yourself as a	lover or figh	ter?
Chaotic Rollow do you	esolve Journ I feel about th	ey: Would yo	ou describe y	yourself as a	lover or figh	ter?
Chaotic R low do you	esolve Journ I feel about th	ey: Would yo	ou describe y	yourself as a	lover or figh	ter?
Chaotic R low do you	esolve Journ I feel about th	ey: Would yo nat? <i>Turn to pag</i>	ou describe y	yourself as a	lover or figh	ter?
Chaotic Rollow do you	esolve Journ I feel about th	ey: Would yo	ou describe y	yourself as a	lover or figh	ter?
Chaotic Rollow do you	esolve Journ I feel about th	ey: Would yo	ou describe y	yourself as a	lover or figh	ter?
Chaotic R low do you	esolve Journ I feel about th	ey: Would yo	ou describe y	yourself as a	lover or figh	ter?
Chaotic R.	esolve Journ	ey: Would yo	ou describe y	yourself as a	lover or figh	ter?
Chaotic R.	esolve Journ	ey: Would yo	ou describe y	yourself as a	lover or figh	ter?
Chaotic Rollow do you	esolve Journ	ey: Would yo	ou describe y	yourself as a	lover or figh	ter?
Chaotic Rollow do you	esolve Journ	ey: Would you	ou describe y	yourself as a	lover or figh	ter?
Chaotic R.	esolve Journ	ey: Would yo	ou describe y	yourself as a	lover or figh	ter?
Chaotic R.	esolve Journ	ey: Would yo	ou describe y	yourself as a	lover or figh	ter?
Chaotic R	esolve Journal feel about the	ey: Would yo	ou describe y	yourself as a	lover or figh	ter?
Chaotic Row do you	esolve Journal feel about the	ey: Would yo	ou describe y	yourself as a	lover or figh	ter?

	our definition of happy and what makes you happy? Turn to page 33
_	
_	
S	elf-discovery Journey: What talents do you have? How do you feel about
S	elf-discovery Journey: What talents do you have? How do you feel about nem? Turn to page 33
S	elf-discovery Journey: What talents do you have? How do you feel about nem? Turn to page 33
S	elf-discovery Journey: What talents do you have? How do you feel about nem? Turn to page 33
Sth	elf-discovery Journey: What talents do you have? How do you feel about nem? Turn to page 33
S	elf-discovery Journey: What talents do you have? How do you feel about nem? Turn to page 33
Str	elf-discovery Journey: What talents do you have? How do you feel about nem? Turn to page 33
Sth	elf-discovery Journey: What talents do you have? How do you feel about nem? Turn to page 33
Str	elf-discovery Journey: What talents do you have? How do you feel about nem? Turn to page 33
Str	elf-discovery Journey: What talents do you have? How do you feel about nem? Turn to page 33
Sth	elf-discovery Journey: What talents do you have? How do you feel about nem? Turn to page 33
Str	elf-discovery Journey: What talents do you have? How do you feel about nem? Turn to page 33
Str	elf-discovery Journey: What talents do you have? How do you feel about nem? Turn to page 33
Str	elf-discovery Journey: What talents do you have? How do you feel about nem? Turn to page 33
Sth	elf-discovery Journey: What talents do you have? How do you feel about nem? Turn to page 33
Sth	elf-discovery Journey: What talents do you have? How do you feel about nem? Turn to page 33
Str	elf-discovery Journey: What talents do you have? How do you feel about nem? Turn to page 33
Sth	elf-discovery Journey: What talents do you have? How do you feel about nem? Turn to page 33
Sth	elf-discovery Journey: What talents do you have? How do you feel about nem? Turn to page 33

future. Write about what mistakes you're going to leave in your rearview mirror. Turn to page 34	
Mending Fences Journey: If you've hurt someone and it ended a relationship or friendship, be the bigger person and apologize. Apologize and move on; you'll feel better. Then determine if you want this relationship back in your life-write about the outcome. <i>Turn to page 34</i>	

at way		rrney: Being happy is a choice. Choose to the choosing to be happy? <i>Turn to page 35</i>	
			*
Spiritual he last th	Journey: Do y	you pray? How important is prayer in you d about? <i>Turn to page 35</i>	r life? What was
Spiritual he last th	Journey: Do ying you prayed	you pray? How important is prayer in you d about? <i>Turn to page</i> 35	r life? What was
Spiritual he last th	Journey: Do ying you prayed	you pray? How important is prayer in you d about? <i>Turn to page</i> 35	r life? What was
Spiritual he last th	Journey: Do y ing you prayed	you pray? How important is prayer in you d about? <i>Turn to page 35</i>	r life? What was
Spiritual he last th	Journey: Do ying you prayed	you pray? How important is prayer in you d about? <i>Turn to page 35</i>	r life? What was
Spiritual he last th	Journey: Do ying you prayed	you pray? How important is prayer in you d about? <i>Turn to page 35</i>	r life? What was
Spiritual he last th	Journey: Do y ing you prayed	you pray? How important is prayer in you d about? <i>Turn to page 35</i>	r life? What was
Spiritual he last th	Journey: Do y	you pray? How important is prayer in you d about? <i>Turn to page 35</i>	r life? What was
Spiritual he last th	Journey: Do ying you prayed	you pray? How important is prayer in you d about? <i>Turn to page 35</i>	r life? What was
Spiritual he last th	Journey: Do y	you pray? How important is prayer in you d about? <i>Turn to page 35</i>	r life? What was
Spiritual he last th	Journey: Do y	you pray? How important is prayer in you d about? <i>Turn to page 35</i>	r life? What was
Spiritual the last th	Journey: Do y	you pray? How important is prayer in you d about? <i>Turn to page 35</i>	r life? What was
Spiritual the last th	Journey: Do ying you prayed	you pray? How important is prayer in you d about? <i>Turn to page 35</i>	r life? What was
Spiritual the last th	Journey: Do y	you pray? How important is prayer in you d about? <i>Turn to page 35</i>	r life? What was
Spiritual he last th	Journey: Do y	you pray? How important is prayer in you d about? <i>Turn to page 35</i>	r life? What was
Spiritual the last th	Journey: Do y	you pray? How important is prayer in you d about? <i>Turn to page 35</i>	r life? What was

	ge 36		
Iumanitarian	Tours our What do		
Iumanitaria n ou think the wo	Journey: What do	o you think the world needs more of? What do	
Iumanitarian ou think the wo	ı Journey: What do orld needs less of?	O you think the world needs more of? What do Turn to page 36	
Iumanitaria n ou think the wo	I Journey: What doorld needs less of?	o you think the world needs more of? What do Turn to page 36	
Jumanitarian ou think the wo	ı Journey: What do orld needs less of?	D you think the world needs more of? What do Turn to page 36	
Iumanitarian ou think the wo	I Journey: What do orld needs less of?	o you think the world needs more of? What do Turn to page 36	
Humanitarian ou think the wo	ı Journey: What do orld needs less of?	D you think the world needs more of? What do Turn to page 36	
Iumanitarian ou think the wo	Journey: What do	D you think the world needs more of? What do	
Iumanitarian ou think the we	Journey: What do	D you think the world needs more of? What do	
Jumanitarian ou think the we	Journey: What do	D you think the world needs more of? What do	
Iumanitarian	Journey: What do	o you think the world needs more of? What do	
Jumanitarian bu think the we	a Journey: What do	D you think the world needs more of? What do	
Iumanitarian	Journey: What do	o you think the world needs more of? What do	
Iumanitarian	Journey: What do	D you think the world needs more of? What do	
Jumanitarian ou think the we	Journey: What do	D you think the world needs more of? What do	

of. Reas	sure and comfort	Write a letter to yourself in this	s letter. Turn to p	page 37	
Chaoti	Pacabra Jauma	Whon your	faht da vou fi	aht with purpo	aso2 Aro voi
fighting	Resolve Journe for a cause, a pers	ey: When your	fight, do you fig self or do you	ght with purpo just have pett	ose? Are you y fights out (
fighting	or a cause, a pers	ey: When your	fight, do you fig self or do you	ght with purpo just have pett	ose? Are you y fights out (
fighting	or a cause, a pers	ey: When you to soon or for your	fight, do you fig self or do you	ght with purpo just have pett	ose? Are you y fights out (
fighting	or a cause, a pers	ey: When you soon or for your	fight, do you fig self or do you	ght with purpo just have pett	ose? Are you y fights out (
fighting	or a cause, a pers	ey: When your	fight, do you fig self or do you	ght with purpo just have pett	ose? Are you y fights out (
fighting	or a cause, a pers	ey: When you to soon or for your	fight, do you fig self or do you	ght with purpo just have pett	ose? Are you y fights out (
fighting	or a cause, a pers	ey: When you soon or for your	fight, do you fig rself or do you	ght with purpo just have pett	ose? Are you y fights out o
fighting	or a cause, a pers	ey: When your	fight, do you fig self or do you	ght with purpo just have pett	ose? Are you y fights out o
fighting	or a cause, a pers	ey: When your	fight, do you fi	ght with purpo just have pett	ose? Are you y fights out o
fighting	or a cause, a pers	ey: When your	fight, do you fig self or do you	ght with purpo just have pett	ose? Are you y fights out o
fighting	or a cause, a pers	ey: When your	fight, do you fig self or do you	ght with purpo	ose? Are you y fights out o
fighting	or a cause, a pers	ey: When your	fight, do you fig	ght with purpo just have pett	ose? Are you y fights out o
fighting	or a cause, a pers	ey: When your	fight, do you fig	ght with purpo just have pett	ose? Are you y fights out o
fighting	or a cause, a pers	ey: When your	fight, do you fig	ght with purpo just have pett	ose? Are you y fights out o
fighting	or a cause, a pers	ey: When your	fight, do you fig self or do you	ght with purpo just have pett	ose? Are you y fights out o

Achievement Journey: Are there any goals you're afraid to set and if so, what are they? <i>Turn to page 38</i>	
Self-discovery Journey: Aristotle said, "Knowing yourself is the beginning of all wisdom." How much do you know about yourself? <i>Turn to page 38</i>	

g Fences Journey: Do you see the best or worst in people? Write aboview others and how you feel about the way you view them. Do you lo? Turn to page 39
view others and how you feel about the way you view them. Do you lo
view others and how you feel about the way you view them. Do you lo
view others and how you feel about the way you view them. Do you lo
view others and how you feel about the way you view them. Do you lo
view others and how you feel about the way you view them. Do you lo
view others and how you feel about the way you view them. Do you lo
view others and how you feel about the way you view them. Do you lo
view others and how you feel about the way you view them. Do you lo
view others and how you feel about the way you view them. Do you lo
view others and how you feel about the way you view them. Do you lo
view others and how you feel about the way you view them. Do you lo
view others and how you feel about the way you view them. Do you lo
view others and how you feel about the way you view them. Do you lo
view others and how you feel about the way you view them. Do you lo
view others and how you feel about the way you view them. Do you lo
view others and how you feel about the way you view them. Do you lo
view others and how you feel about the way you view them. Do you lo

Self-improvement Journey: Know your self-worth. Your worth is not a product of wealth or popularity. It is how you see yourself and knowing you're valuable. How worthy do you currently see yourself and how can you improve on it? <i>Turn to page 40</i>
·
Spiritual Journey: What makes you feel enlightened and uplifted? Turn to page 40

calling mi					
Humanita the homele	urian Journey: Wi	rite about what	you think the	best ways are	to help
Humanita the homele	urian Journey: Wi	rite about what	you think the	best ways are	to help
Humanita the homele	urian Journey: Wi	rite about what	you think the	best ways are	to help
Humanita the homele	urian Journey: Wi	rite about what	you think the	best ways are	to help
Humanita the homele	urian Journey: Wi	rite about what	you think the	best ways are	to help
Humanita the homele	urian Journey: Wi	rite about what	you think the	best ways are	to help
Humanita the homele	urian Journey: Wi	rite about what	you think the	best ways are	to help
Humanita the homele	urian Journey: Wi	rite about what	you think the	best ways are	to help
Humanita the homele	urian Journey: Wi	rite about what	you think the	best ways are	to help
Humanita the homele	urian Journey: Wi	rite about what	you think the	best ways are	to help
Humanita the homele	urian Journey: Wi	rite about what	you think the	best ways are	to help
Humanita the homele	urian Journey: Wi	rite about what	you think the	best ways are	to help
Humanita the homele	urian Journey: Wi	rite about what	you think the	best ways are	to help
Humanita the homele	urian Journey: Wi	rite about what	you think the	best ways are	to help
Humanita the homele	urian Journey: Wi	rite about what	you think the	best ways are	to help
Humanita the homele	urian Journey: Wi	rite about what	you think the	best ways are	to help
Humanita the homele	arian Journey: Wi	rite about what	you think the	best ways are	to help
Humanita the homele	arian Journey: Wi	rite about what	you think the	best ways are	to help
Humanita the homele	arian Journey: Wi	rite about what	you think the	best ways are	to help
Humanita the homele	arian Journey: Wi	rite about what	you think the	best ways are	to help
Humanita the homele	arian Journey: Wi	rite about what	you think the	best ways are	to help

haotic Resolv	re Journey: Wr ds it. <i>Turn to page</i> -	ite down thinç	gs you're ang	ry about and	I why you
haotic Resolv el anger towar	ve Journey: Wr	ite down thing 42	gs you're ang	ry about and	l why you
haotic Resolv el anger towar	ve Journey: Wr	ite down thing 42	gs you're ang	ry about and	l why you
haotic Resolv el anger towar	ve Journey: Wr	ite down thinç 42	gs you're ang	ry about and	l why you
haotic Resolv el anger towar	ve Journey: Wr	ite down thing 42	gs you're ang	ry about and	l why you
haotic Resolv el anger towar	ve Journey: Wr	ite down thing 42	gs you're ang	ry about and	l why you
haotic Resolv el anger towar	ve Journey: Wr	ite down thing	gs you're ang	ry about and	l why you
haotic Resolv el anger towar	ve Journey: Wr	ite down thing	gs you're ang	ry about and	l why you
haotic Resolv el anger towar	ve Journey: Wr	ite down thing	gs you're ang	ry about and	l why you
haotic Resolvel anger towar	ve Journey: Wr	ite down thing	gs you're ang	ry about and	l why you
haotic Resolv el anger towar	ve Journey: Wr	ite down thing	gs you're ang	ry about and	l why you
haotic Resolv el anger towar	ve Journey: Wr	ite down thing	gs you're ang	ry about and	l why you
haotic Resolv el anger towar	ve Journey: Wr	ite down thing	gs you're ang	ry about and	l why you
haotic Resolvel anger towar	ve Journey: Wr	ite down thing	gs you're ang	ry about and	l why you
haotic Resolvel anger towar	ve Journey: Wr	ite down thing	gs you're ang	ry about and	l why you

Self-discovery Journey further? Turn to page 43	: Think about exploring. What do you want to explore
Self-discovery Journey further? <i>Turn to page 43</i>	: Think about exploring. What do you want to explore
Self-discovery Journey further? <i>Turn to page 43</i>	Think about exploring. What do you want to explore
Self-discovery Journey further? <i>Turn to page 43</i>	Think about exploring. What do you want to explore
Self-discovery Journey further? <i>Turn to page 43</i>	: Think about exploring. What do you want to explore
Self-discovery Journey further? <i>Turn to page 43</i>	: Think about exploring. What do you want to explore
Self-discovery Journey further? <i>Turn to page 43</i>	: Think about exploring. What do you want to explore
Self-discovery Journey further? <i>Turn to page 43</i>	Think about exploring. What do you want to explore
Self-discovery Journey further? Turn to page 43	Think about exploring. What do you want to explore
Self-discovery Journey further? Turn to page 43	Think about exploring. What do you want to explore
Self-discovery Journey further? Turn to page 43	: Think about exploring. What do you want to explore
Self-discovery Journey further? Turn to page 43	: Think about exploring. What do you want to explore
Self-discovery Journey further? Turn to page 43	Think about exploring. What do you want to explore
Self-discovery Journey further? Turn to page 43	Think about exploring. What do you want to explore
Self-discovery Journey further? Turn to page 43	Think about exploring. What do you want to explore
Self-discovery Journey further? Turn to page 43	Think about exploring. What do you want to explore
Self-discovery Journey further? Turn to page 43	Think about exploring. What do you want to explore

our self-este ople? <i>Turn to</i>	eem? Descri o page 44	ibe your
	,	
	our self-est	our self-esteem? Descrople? Turn to page 44

animal? H	low do you co	onnect with yo	ur spirit anima	il? If you don't I	at is your spirit know, then go i
animal? H	low do you co	onnect with yo	ur spirit anima	s" and if so wh Il? If you don't I adings. <i>Turn to pa</i>	know, then go i
animal? H	low do you co	onnect with yo	ur spirit anima	il? If you don't I	know, then go i
animal? H	low do you co	onnect with yo	ur spirit anima	il? If you don't I	know, then go i
animal? H	low do you co	onnect with yo	ur spirit anima	il? If you don't I	know, then go i
animal? H	low do you co	onnect with yo	ur spirit anima	il? If you don't I	know, then go i
animal? H	low do you co	onnect with yo	ur spirit anima	il? If you don't I	know, then go i
animal? H	low do you co	onnect with yo	ur spirit anima	il? If you don't I	know, then go i
animal? H	low do you co	onnect with yo	ur spirit anima	il? If you don't I	know, then go i
animal? H	low do you co	onnect with yo	ur spirit anima	il? If you don't I	know, then go i
animal? H	low do you co	onnect with yo	ur spirit anima	il? If you don't I	know, then go i
animal? H	low do you co	onnect with yo	ur spirit anima	il? If you don't I	know, then go i
animal? H	low do you co	onnect with yo	ur spirit anima	il? If you don't I	know, then go i
animal? H	low do you co	onnect with yo	ur spirit anima	il? If you don't I	know, then go i

Destination where you wa						
Iumanitaria	ın Journey:	Think about v	ways you car	n help the env	vironment. V	Vrite
Iumanitaria plan of actio	in Journey: n you can im	Think about v	ways you car ome point in	n help the en your life. <i>Turn</i>	vironment. V n to page 46	Vrite
Jumanitaria plan of actio	n Journey: n you can im	Think about v	ways you car ome point in	n help the env your life. <i>Turr</i>	vironment. V n to page 46	Vrite
Humanitaria plan of actio	i n Journey: n you can im	Think about v	ways you car ome point in	n help the en your life. <i>Turn</i>	vironment. V n to page 46	Vrite
Humanitaria plan of actio	in Journey: n you can im	Think about v	ways you car ome point in	help the envyour life. <i>Turn</i>	vironment. V n to page 46	Vrite
Humanitaria plan of actio	in Journey: n you can im	Think about v	ways you car ome point in	n help the en your life. <i>Turn</i>	vironment. V n to page 46	Vrite
Humanitaria plan of actio	in Journey: n you can im	Think about v	ways you car ome point in	n help the en your life. <i>Turn</i>	vironment. V n to page 46	Vrite
Humanitaria plan of actio	in Journey: n you can im	Think about v	ways you car ome point in	help the envyour life. <i>Turn</i>	vironment. V n to page 46	Vrite
Humanitaria plan of actio	In Journey: n you can im	Think about v	ways you car ome point in	n help the env your life. <i>Turn</i>	vironment. V n to page 46	Vrite
Humanitaria plan of actio	in Journey: n you can im	Think about v	ways you car ome point in	n help the en your life. <i>Turn</i>	vironment. V n to page 46	Vrite
Humanitari z plan of actio	in Journey: n you can im	Think about v	ways you car ome point in	n help the en your life. <i>Turn</i>	vironment. V n to page 46	Vrite
Humanitaria plan of actio	in Journey: n you can im	Think about v	ways you car ome point in	n help the envyour life. <i>Turn</i>	vironment. V	Vrite
Humanitaria plan of actio	n Journey:	Think about v	ways you car ome point in	n help the en your life. <i>Turn</i>	vironment. V n to page 46	Vrite
Humanitari z plan of actio	in Journey: n you can im	Think about v	ways you car ome point in	n help the en your life. <i>Turn</i>	vironment. V n to page 46	Vrite
Humanitaria plan of actio	in Journey: n you can im	Think about v	ways you car ome point in	n help the en your life. <i>Turn</i>	vironment. V	Vrite

Chaotic Res	solve Journey: Ho	w can you cha	nge your outlo	ook about the thing
Chaotic Res that make you	olve Journey: Ho u angry? What car	w can you cha n you do to imp	nge your outlo prove here? <i>Tur</i>	ook about the thing on to page 47
Chaotic Res that make you	colve Journey: Ho u angry? What car	w can you cha n you do to imp	nge your outlo prove here? <i>Tur</i>	ook about the thing on to page 47
Chaotic Res that make you	colve Journey: Ho u angry? What car	w can you cha n you do to imp	nge your outlo prove here? <i>Tur</i>	ook about the thing on to page 47
Chaotic Res that make you	colve Journey: Ho u angry? What car	w can you cha I you do to imp	nge your outlo prove here? <i>Tur</i>	ook about the thing on to page 47
Chaotic Res	colve Journey: Ho u angry? What car	w can you cha n you do to imp	nge your outlo prove here? <i>Tur</i>	ook about the thing on to page 47
Chaotic Res	olve Journey: Ho u angry? What car	w can you cha n you do to imp	nge your outlo prove here? <i>Tur</i>	ook about the thing on to page 47
Chaotic Res	colve Journey: Ho u angry? What car	w can you cha n you do to imp	nge your outlo prove here? <i>Tur</i>	ook about the thing on to page 47
Chaotic Res	colve Journey: Ho u angry? What car	w can you cha	nge your outlo prove here? <i>Tur</i>	ook about the thing on to page 47
Chaotic Res	colve Journey: Ho u angry? What car	w can you cha	nge your outlo prove here? <i>Tur</i>	ook about the thing on to page 47
Chaotic Res	colve Journey: Ho u angry? What car	w can you cha	nge your outlo prove here? <i>Tur</i>	ook about the thing to page 47
Chaotic Res	colve Journey: Ho u angry? What car	w can you cha	nge your outlo	ook about the thing to page 47
Chaotic Res	colve Journey: Ho u angry? What car	ow can you cha	nge your outlo	ook about the thing to page 47
Chaotic Res	colve Journey: Ho u angry? What car	w can you cha	nge your outlo prove here? <i>Tur</i>	ook about the thing to page 47
Chaotic Res	colve Journey: Ho	w can you cha	nge your outlo prove here? <i>Tur</i>	ook about the thing to page 47
Chaotic Res	colve Journey: Ho	w can you cha	nge your outlo prove here? <i>Tur</i>	ook about the thing to page 47

iano sure y	e unrealistic expectations but at the same time challenge yourself. your goals are attainable. Write about your goals. <i>Turn to page 48</i>	
	· ·	
Self-discov	very Journey: What is missing from your life? What do you need	
note of Tu	rn to page 48	
HOLE OF TU	rn to page 48	
note of? Tu	rn to page 48	
nore or? Tu	rn to page 48	
TIOLE OF THE	rn to page 48	
TIOLE OF THE	rn to page 48	
IOI & OT? Tu.	rn to page 48	
IOIE OT? Tu.	rn to page 48	
TIOLE OF THE	rn to page 48	
TIOLE OF THE	rn to page 48	
NOIS OF THE	rn to page 48	
HOLE OF THE	rn to page 48	
HOLE OF THE	rn to page 48	
HOLE OF THE	rn to page 48	
HOLE OF THE	rn to page 48	
HOLE OF THE	rn to page 48	

		8			
Mendin	g Fences Jour	ney: Use the	proverb, "pec	ple who live in	glass houses
shouldn't	g Fences Jour throw stones." Turn to page 49	ney: Use the Now write w	proverb, "pec hat this means	ple who live in s to you and ho	glass houses ow it applies to
shouldn't	throw stones."	rney: Use the Now write w	proverb, "pec hat this means	ple who live in s to you and ho	glass houses ow it applies to
shouldn't	throw stones."	:ney: Use the Now write w	proverb, "pec hat this means	ple who live in s to you and ho	glass houses ow it applies to
shouldn't	throw stones."	rney: Use the Now write w	proverb, "pec hat this means	ple who live in s to you and ho	glass houses ow it applies to
shouldn't	throw stones."	rney: Use the Now write w	proverb, "pec hat this means	ple who live in s to you and ho	glass houses ow it applies to
shouldn't	throw stones."	rney: Use the Now write w	proverb, "pec hat this means	ple who live in	glass houses ow it applies to
shouldn't	throw stones."	Tney: Use the Now write w	proverb, "pec hat this means	ple who live in	glass houses ow it applies to
shouldn't	throw stones."	rney: Use the Now write w	proverb, "pec hat this means	ple who live in	glass houses ow it applies to
shouldn't	throw stones."	rney: Use the Now write w	proverb, "pec hat this means	ple who live in	glass houses ow it applies to
shouldn't	throw stones."	rney: Use the Now write w	proverb, "pec hat this means	ple who live in	glass houses ow it applies to
shouldn't	throw stones."	rney: Use the Now write w	proverb, "pec hat this means	ple who live in	glass houses ow it applies to
shouldn't	throw stones."	rney: Use the Now write w	proverb, "peo hat this means	ple who live in	glass houses ow it applies to
shouldn't	throw stones."	rney: Use the Now write w	proverb, "peo hat this means	ple who live in	glass houses ow it applies to
shouldn't	throw stones."	rney: Use the Now write w	proverb, "peo hat this means	ple who live in	glass houses ow it applies to
shouldn't	throw stones."	rney: Use the Now write w	proverb, "peo hat this means	ple who live in	glass houses ow it applies to
shouldn't	throw stones."	rney: Use the Now write w	proverb, "pechat this means	ple who live in	glass houses ow it applies to
shouldn't	throw stones."	rney: Use the Now write w	proverb, "pechat this means	ple who live in	glass houses ow it applies to

about why you do or do not believe in astrology and any impact it has on your life.	Self-improvement Journey: Write self-loving affirmations. Practice saying them to yourself every day and write about if they helped you. $Turn to page 50$	
about why you do or do not believe in astrology and any impact it has on your life.		
about why you do or do not believe in astrology and any impact it has on your life.		
about why you do or do not believe in astrology and any impact it has on your life.		
about why you do or do not believe in astrology and any impact it has on your life.		
about why you do or do not believe in astrology and any impact it has on your life.		
about why you do or do not believe in astrology and any impact it has on your life.		
about why you do or do not believe in astrology and any impact it has on your life.		
about why you do or do not believe in astrology and any impact it has on your life.		
about why you do or do not believe in astrology and any impact it has on your life.		
about why you do or do not believe in astrology and any impact it has on your life.		
	Spiritual Journey: Do you believe in astrology? If so, what's your sign? Write about why you do or do not believe in astrology and any impact it has on your life. <i>Turn to page 50</i>	

Hu	manitarian Journey: Do something nice for a friend. Write about why you
Hu	manitarian Journey: Do something nice for a friend. Write about why you se that friend and what they mean to you. <i>Turn to page 51</i>
Hu	manitarian Journey: Do something nice for a friend. Write about why you se that friend and what they mean to you. <i>Turn to page 51</i>
Hu	manitarian Journey: Do something nice for a friend. Write about why you se that friend and what they mean to you. <i>Turn to page 51</i>
Hu	manitarian Journey: Do something nice for a friend. Write about why you se that friend and what they mean to you. <i>Turn to page 51</i>
Hu	manitarian Journey: Do something nice for a friend. Write about why you se that friend and what they mean to you. <i>Turn to page 51</i>
Hu	manitarian Journey: Do something nice for a friend. Write about why you se that friend and what they mean to you. Turn to page 51
Hu	manitarian Journey: Do something nice for a friend. Write about why you se that friend and what they mean to you. <i>Turn to page 51</i>
Hu	manitarian Journey: Do something nice for a friend. Write about why you se that friend and what they mean to you. <i>Turn to page 51</i>
Hu	manitarian Journey: Do something nice for a friend. Write about why you se that friend and what they mean to you. <i>Turn to page 51</i>
Hu	manitarian Journey: Do something nice for a friend. Write about why you se that friend and what they mean to you. Turn to page 51
Hu	manitarian Journey: Do something nice for a friend. Write about why you se that friend and what they mean to you. Turn to page 51
Hu	manitarian Journey: Do something nice for a friend. Write about why you se that friend and what they mean to you. Turn to page 51
Hucho	manitarian Journey: Do something nice for a friend. Write about why you se that friend and what they mean to you. Turn to page 51
Hu	manitarian Journey: Do something nice for a friend. Write about why you se that friend and what they mean to you. Turn to page 51
Hu	manitarian Journey: Do something nice for a friend. Write about why you se that friend and what they mean to you. Turn to page 51
Hucho	manitarian Journey: Do something nice for a friend. Write about why you se that friend and what they mean to you. Turn to page 51
Hucho	manitarian Journey: Do something nice for a friend. Write about why you se that friend and what they mean to you. Turn to page 51
Huchc	manitarian Journey: Do something nice for a friend. Write about why you se that friend and what they mean to you. Turn to page 51

open up. Turn to	out if it helped you, what happened and if anonymity helped you page 52
7h 4: - D 1	I
Chaotic Resolunresolved thin	Ive Journey: What do you have that is unresolved? Write about ags in your life that are keeping you from inner peace. <i>Turn to page 52</i>
Chaotic Resolunresolved thin	Ive Journey: What do you have that is unresolved? Write about gs in your life that are keeping you from inner peace. <i>Turn to page 52</i>
Chaotic Resolunresolved thin	Ive Journey: What do you have that is unresolved? Write about ligs in your life that are keeping you from inner peace. <i>Turn to page 52</i>
Chaotic Resolunresolved thin	Ive Journey: What do you have that is unresolved? Write about ags in your life that are keeping you from inner peace. Turn to page 52
Chaotic Resolunresolved thin	Ive Journey: What do you have that is unresolved? Write about 1935 in your life that are keeping you from inner peace. <i>Turn to page 52</i>
Chaotic Resolunresolved thin	Ive Journey: What do you have that is unresolved? Write about ags in your life that are keeping you from inner peace. Turn to page 52
Chaotic Resolunresolved thin	Ive Journey: What do you have that is unresolved? Write about 1935 in your life that are keeping you from inner peace. Turn to page 52
Chaotic Resolunresolved thin	Ive Journey: What do you have that is unresolved? Write about ags in your life that are keeping you from inner peace. Turn to page 52
Chaotic Resolunresolved thin	Ive Journey: What do you have that is unresolved? Write about ags in your life that are keeping you from inner peace. Turn to page 52
Chaotic Resolunresolved thin	Ive Journey: What do you have that is unresolved? Write about ags in your life that are keeping you from inner peace. Turn to page 52
Chaotic Resolunresolved thin	Ive Journey: What do you have that is unresolved? Write about the ings in your life that are keeping you from inner peace. Turn to page 52

Self-discovery Journey: What are your favorite hobbies and how do they mak you feel? Turn to page 53	affirmation	ement Journey: Seeing your dreams and goals daily reminds you u're working for. Find a creative way to display your goals and positive ons that will help you reach your goals. How will you do this? <i>Turn to page 5</i>
you feel? Turn to page 53		
you feel? Turn to page 53		
you feel? Turn to page 53		
you feel? Turn to page 53		
you feel? Turn to page 53		
you feel? Turn to page 53		
you feel? Turn to page 53		
you feel? Turn to page 53		
you feel? Turn to page 53		
you feel? Turn to page 53		
you feel? Turn to page 53		
you feel? Turn to page 53		
you feel? Turn to page 53		
you feel? Turn to page 53		
you feel? Turn to page 53		
you feel? Turn to page 53		
you feel? Turn to page 53		
	Self-dis	covery Journey: What are your favorite hobbies and how do they mak
	Self-dis you feel	scovery Journey: What are your favorite hobbies and how do they mak? Turn to page 53
	Self-dis you feel	scovery Journey: What are your favorite hobbies and how do they mak? Turn to page 53
	Self-dis	covery Journey: What are your favorite hobbies and how do they mak? Turn to page 53
	Self-dis you feel	scovery Journey: What are your favorite hobbies and how do they mak? Turn to page 53
	Self-dis you feel	scovery Journey: What are your favorite hobbies and how do they mak? Turn to page 53
	Self-dis you feel	scovery Journey: What are your favorite hobbies and how do they mak? Turn to page 53
	Self-dis you feel	scovery Journey: What are your favorite hobbies and how do they mak? Turn to page 53
	Self-dis you feel	scovery Journey: What are your favorite hobbies and how do they mak? Turn to page 53
	Self-dis you feel	scovery Journey: What are your favorite hobbies and how do they mak? Turn to page 53
	Self-dis	scovery Journey: What are your favorite hobbies and how do they mak? Turn to page 53
	Self-dis	Scovery Journey: What are your favorite hobbies and how do they make? Turn to page 53
	Self-dis you feel	? Turn to page 53
	Self-dis you feel	? Turn to page 53
	Self-dis	? Turn to page 53
	Self-dis you feel	? Turn to page 53

Writing a New Chapter Journey: Mistakes are different than bad decisions. Most mistakes are unintentional. Write about bad decisions you keep repeating and how you need to correct this behavior. <i>Turn to page 54</i>	
Mending Fences Journey: Stop trying to change other people. Make an effort to accept people the way they are. Why do you feel the need to change others? <i>Turn to page 54</i>	
to accept people the way they are. Why do you feel the need to change others?	
to accept people the way they are. Why do you feel the need to change others?	
to accept people the way they are. Why do you feel the need to change others?	
to accept people the way they are. Why do you feel the need to change others?	
to accept people the way they are. Why do you feel the need to change others?	
to accept people the way they are. Why do you feel the need to change others?	
to accept people the way they are. Why do you feel the need to change others?	
to accept people the way they are. Why do you feel the need to change others?	
to accept people the way they are. Why do you feel the need to change others?	
to accept people the way they are. Why do you feel the need to change others?	

Spiritual Journey: Be still. Try deep meditation, combined with breathing exercises or other practices that help you still the mind. Write about this journe Turn to page 55	carrov	vercome your insecurities? Turn to page 55
exercises or other practices that help you still the mind. Write about this journe		
exercises or other practices that help you still the mind. Write about this journey		
exercises or other practices that help you still the mind. Write about this journey		
exercises or other practices that help you still the mind. Write about this journey		
exercises or other practices that help you still the mind. Write about this journey		
exercises or other practices that help you still the mind. Write about this journey		
exercises or other practices that help you still the mind. Write about this journey		
exercises or other practices that help you still the mind. Write about this journey		
exercises or other practices that help you still the mind. Write about this journey		
exercises or other practices that help you still the mind. Write about this journey		
exercises or other practices that help you still the mind. Write about this journey		
exercises or other practices that help you still the mind. Write about this journey		
exercises or other practices that help you still the mind. Write about this journey		
exercises or other practices that help you still the mind. Write about this journey		
exercises or other practices that help you still the mind. Write about this journey		
exercises or other practices that help you still the mind. Write about this journey		
exercises or other practices that help you still the mind. Write about this journey		
exercises or other practices that help you still the mind. Write about this journey		
exercises or other practices that help you still the mind. Write about this journey		
exercises or other practices that help you still the mind. Write about this journey		
	exerci	ises or other practices that help you still the mind. Write about this journe
	exerci	ises or other practices that help you still the mind. Write about this journe
	exerci	ises or other practices that help you still the mind. Write about this journe
	exerci	ises or other practices that help you still the mind. Write about this journe
	exerci	ises or other practices that help you still the mind. Write about this journe
	exerci	ises or other practices that help you still the mind. Write about this journe
	exerci	ises or other practices that help you still the mind. Write about this journe
	exerci	ises or other practices that help you still the mind. Write about this journe
	exerci	ises or other practices that help you still the mind. Write about this journe
	exerci	ises or other practices that help you still the mind. Write about this journe
	exerci	ises or other practices that help you still the mind. Write about this journe
	exerci	ises or other practices that help you still the mind. Write about this journe
	exerci	ises or other practices that help you still the mind. Write about this journe
	exerci	ises or other practices that help you still the mind. Write about this journe
	exerci	ises or other practices that help you still the mind. Write about this journe

choose that fie	eld? Turn to pag	re 56			why did you	
	1 0					
Iumanitaria	n Journey: \	What's the ni	cest thing so	meone has e	ver done for	
Iumanitaria ou? Do you h	n Journey: \ ave any plans	What's the ni s to pay it for	cest thing so ward? <i>Turn to</i>	meone has e ^v	ver done for	
Iumanitaria ou? Do you h	n Journey: \ ave any plans	What's the ni s to pay it foi	cest thing so ward? <i>Turn to</i>	meone has e ^v	ver done for	
Iumanitaria pu? Do you h	n Journey: \ ave any plan:	What's the ni s to pay it for	cest thing so ward? <i>Turn to</i>	meone has e ^v page 56	ver done for	
Iumanitaria bu? Do you h	n Journey: \ ave any plan:	What's the ni s to pay it for	cest thing so ward? <i>Turn to</i>	meone has e [,]	ver done for	
lumanitaria bu? Do you h	n Journey: \ ave any plan:	What's the ni s to pay it foi	cest thing sol ward? <i>Turn to</i>	meone has e ^v	ver done for	
Iumanitaria pu? Do you h	n Journey: \ ave any plan:	What's the ni s to pay it for	cest thing so ward? <i>Turn to</i>	meone has e ^v	ver done for	
Iumanitaria bu? Do you h	n Journey: \ ave any plan:	What's the ni s to pay it for	cest thing so ward? <i>Turn to</i>	meone has e [,]	ver done for	
Iumanitaria pu? Do you h	n Journey: \ ave any plan:	What's the ni s to pay it foi	cest thing so ward? <i>Turn to</i>	meone has e ^v	ver done for	
lumanitaria bu? Do you h	n Journey: \ ave any plan:	What's the ni s to pay it for	cest thing so ward? <i>Turn to</i>	meone has e ^v	ver done for	
Iumanitaria ou? Do you h	n Journey: \ ave any plan:	What's the ni s to pay it for	cest thing so ward? <i>Turn to</i>	meone has e ^v	ver done for	
Iumanitaria ou? Do you h	n Journey: \ ave any plans	What's the ni	cest thing so ward? <i>Turn to</i>	meone has e [,]	ver done for	
Jumanitaria pu? Do you h	n Journey: \ ave any plans	What's the ni	cest thing sol	meone has ev	ver done for	
Jumanitaria bu? Do you h	n Journey: \ ave any plan:	What's the ni s to pay it for	cest thing so ward? Turn to	meone has e	ver done for	
Iumanitaria ou? Do you h	n Journey: \ ave any plans	What's the ni s to pay it for	cest thing so ward? Turn to	meone has e	ver done for	
Jumanitaria ou? Do you h	n Journey: \ ave any plans	What's the ni	cest thing so ward? <i>Turn to</i>	meone has e ^v	ver done for	

or ask for h videos. Wr	ite about your	meditation	experience. 7	urn to page 57		
		1				
Chaotic I	Resolve Journ Write about wh	ney: How ca	n you start re	solving the u	nresolved area	as i
Chaotic I your life?	Resolve Journ Write about wh	ney: How ca here you pla	n you start re n to start. <i>Turr</i>	solving the u	nresolved area	as i
Chaotic I your life?	Resolve Journ Write about wh	ney: How ca here you pla	n you start re n to start. <i>Turr</i>	solving the u a to page 57	nresolved area	as i
Chaotic I your life? \	Resolve Journ Write about wh	ney: How cal here you pla	n you start re n to start. <i>Turr</i>	solving the u 11 to page 57	nresolved area	as i
Chaotic I your life?	Resolve Journ Write about wh	ney: How ca here you pla	n you start re n to start. <i>Turn</i>	solving the u a to page 57	nresolved area	as i
Chaotic I your life? \	Resolve Journ Write about wh	ney: How ca here you pla	n you start re n to start. <i>Turr</i>	solving the u 11 to page 57	nresolved area	as i
Chaotic I your life? \	Resolve Journ Write about wh	ney: How ca here you pla	n you start re n to start. <i>Turr</i>	solving the u a to page 57	nresolved area	as i
Chaotic I your life?	Resolve Journ Write about wh	ney: How ca here you pla	n you start re n to start. <i>Turn</i>	solving the u a to page 57	nresolved area	as i
Chaotic I your life?	Resolve Journ	ney: How ca here you pla	n you start re: n to start. <i>Turr</i>	solving the u	nresolved area	as i
Chaotic I your life? \	Resolve Journ	ney: How ca here you pla	n you start re n to start. <i>Turr</i>	solving the u	nresolved area	as i
Chaotic I your life?	Resolve Journ Write about wh	ney: How cal	n you start re	solving the u	nresolved area	as i
Chaotic I your life? \	Resolve Journ	ney: How ca here you pla	n you start re n to start. <i>Turr</i>	solving the u	nresolved area	as i
Chaotic I your life?	Resolve Journ	ney: How ca	n you start re	solving the u	nresolved area	as i
Chaotic I your life?	Resolve Journ Write about wi	ney: How can here you pla	n you start re	solving the u	nresolved area	as i

	Achievement Journey: Reduce your distractions. Make a list of things that distract you. Now write about how you can avoid those distractions. <i>Turn to page 58</i>
,	Self-discovery Journey: If you could travel anywhere in the world you want, where would you go and why? What speaks to you about this place? <i>Turn to page 58</i>

you. Write about dis				
		,		
Mending Fences J	ourney: Have you	and a family mer	mber had a fallir	ng out?
Have you been able	ourney: Have you to rectify that rela	and a family mer tionship? How is y	mber had a falli our relationship	ng out? o now?
Mending Fences J Have you been able Turn to page 59	ourney: Have you to rectify that rela	and a family mer tionship? How is y	mber had a falli our relationship	ng out? now?
Have you been able	ourney: Have you to rectify that rela	and a family mer tionship? How is y	mber had a falli our relationship	ng out? o now?
Have you been able	ourney: Have you to rectify that rela	and a family mer tionship? How is y	mber had a falli our relationship	ng out? now?
Have you been able	ourney: Have you to rectify that rela	and a family mer tionship? How is y	mber had a falli rour relationship	ng out? o now?
Have you been able	ourney: Have you to rectify that rela	and a family mer tionship? How is y	mber had a falli rour relationship	ng out? o now?
Have you been able	ourney: Have you to rectify that rela	and a family mer tionship? How is y	mber had a falli rour relationship	ng out? o now?
Have you been able	ourney: Have you to rectify that rela	and a family mer tionship? How is y	mber had a falli rour relationship	ng out? o now?
Have you been able	ourney: Have you to rectify that rela	and a family mer tionship? How is y	mber had a falli rour relationship	ng out? o now?
Have you been able	ourney: Have you to rectify that rela	and a family mer tionship? How is y	mber had a falli rour relationship	ng out? o now?
Have you been able	ourney: Have you to rectify that rela	and a family mer tionship? How is y	mber had a falli rour relationship	ng out? o now?
Have you been able	ourney: Have you to rectify that rela	and a family mer tionship? How is y	mber had a falli rour relationship	ng out? o now?
Have you been able	ourney: Have you to rectify that rela	and a family mer tionship? How is y	mber had a falli rour relationship	ng out? o now?
Have you been able	ourney: Have you to rectify that rela	and a family mer tionship? How is y	mber had a falli rour relationship	ng out? o now?
Have you been able	ourney: Have you to rectify that rela	and a family mer tionship? How is y	mber had a falli rour relationship	ng out? o now?
Have you been able	ourney: Have you to rectify that rela	and a family mer tionship? How is y	mber had a falli rour relationship	ng out? o now?
Have you been able	ourney: Have you to rectify that rela	and a family mer tionship? How is y	mber had a falli rour relationship	ng out? o now?
Have you been able	ourney: Have you to rectify that rela	and a family mer tionship? How is y	mber had a falli rour relationship	ng out? o now?

piritua our spiri	Journey: You need to find a way to connect to others that connect to tual similarities. How can you do this? <i>Turn to page 60</i>
piritua l our spiri	Journey: You need to find a way to connect to others that connect to tual similarities. How can you do this? <i>Turn to page 60</i>
piritua l our spiri	Journey: You need to find a way to connect to others that connect to tual similarities. How can you do this? <i>Turn to page 60</i>
piritua l our spiri	Journey: You need to find a way to connect to others that connect to tual similarities. How can you do this? <i>Turn to page 60</i>
piritua l our spiri	l Journey: You need to find a way to connect to others that connect to tual similarities. How can you do this? <i>Turn to page 60</i>
piritual our spiri	l Journey: You need to find a way to connect to others that connect to tual similarities. How can you do this? <i>Turn to page 60</i>
piritua our spiri	l Journey: You need to find a way to connect to others that connect to tual similarities. How can you do this? <i>Turn to page 60</i>
piritua l	l Journey: You need to find a way to connect to others that connect to tual similarities. How can you do this? <i>Turn to page 60</i>
piritual our spiri	l Journey: You need to find a way to connect to others that connect to tual similarities. How can you do this? <i>Turn to page 60</i>
piritua our spiri	L Journey: You need to find a way to connect to others that connect to tual similarities. How can you do this? Turn to page 60
piritua l	I Journey: You need to find a way to connect to others that connect to tual similarities. How can you do this? Turn to page 60
piritua l	l Journey: You need to find a way to connect to others that connect to tual similarities. How can you do this? Turn to page 60
Spiritua l	L Journey: You need to find a way to connect to others that connect to tual similarities. How can you do this? Turn to page 60
Spiritual our spiri	I Journey: You need to find a way to connect to others that connect to tual similarities. How can you do this? Turn to page 60

Destination rewarding v	vork is always hard	: 1 urn to page 01		
			1	
*				
Humanita	rian Journey: Give	e out at least 25	or more comp	oliments to peopl
you know a	rian Journey: Give nd strangers all in o t. Write about how	one day. Be mir	dful and put th	ought into the
you know a	nd strangers all in o	one day. Be mir	dful and put th	ought into the
you know a	nd strangers all in o	one day. Be mir	dful and put th	ought into the
you know a	nd strangers all in o	one day. Be mir	dful and put th	ought into the
you know a	nd strangers all in o	one day. Be mir	dful and put th	ought into the
you know a	nd strangers all in o	one day. Be mir	dful and put th	ought into the
you know a	nd strangers all in o	one day. Be mir	dful and put th	ought into the
you know a	nd strangers all in o	one day. Be mir	dful and put th	ought into the
you know a	nd strangers all in o	one day. Be mir	dful and put th	ought into the
you know a	nd strangers all in o	one day. Be mir	dful and put th	ought into the
you know a	nd strangers all in o	one day. Be mir	dful and put th	ought into the
you know a	nd strangers all in o	one day. Be mir	dful and put th	ought into the
you know a	nd strangers all in o	one day. Be mir	dful and put th	ought into the
you know a	nd strangers all in o	one day. Be mir	dful and put th	ought into the
you know a	nd strangers all in o	one day. Be mir	dful and put th	ought into the

Overcomer's Journey: Read a book, blog or article that deals with a particular fear you have. Write about what you read and if it helped you. Did you learn anything? <i>Turn to page 62</i>	ar
Chaotic Resolve Journey: Do you lash out at people? What have you ever lashed out about? <i>Turn to page 62</i>	

Self-disco	very Journey: \	Wake up and	d seize the da	ay. What does	s this mean to
Self-disco you and wr	very Journey: ite about how y	Wake up and ou seized the	d seize the da e day. <i>Turn to j</i>	ay. What does	s this mean to
Self-disco you and wr	very Journey: ite about how y	Wake up and ou seized th	d seize the da e day. <i>Turn to p</i>	ay. What does	s this mean to
Self-disco you and wr	very Journey: 'ite about how y	Wake up and ou seized the	d seize the da e day. <i>Turn to p</i>	ay. What does	s this mean to
Self-disco you and wr	very Journey: ite about how y	Wake up and ou seized th	d seize the da e day. <i>Turn to j</i>	ay. What does page 63	s this mean to
Self-disco you and wr	very Journey: ite about how y	Wake up and ou seized the	d seize the da e day. <i>Turn to j</i>	ay. What does	s this mean to
Self-disco you and wr	very Journey: ite about how y	Wake up and ou seized the	d seize the da e day. <i>Turn to j</i>	ay. What does	s this mean to
Self-disco you and wr	very Journey: ite about how y	Wake up and ou seized the	d seize the da e day. <i>Turn to j</i>	ay. What does	s this mean to
Self-disco you and wr	very Journey: ite about how y	Wake up and	d seize the da e day. <i>Turn to j</i>	ay, What does	s this mean to
Self-disco you and wr	very Journey: ite about how y	Wake up and	d seize the da e day. <i>Turn to j</i>	ay. What does	s this mean to
Self-disco you and wr	very Journey: ite about how y	Wake up and	d seize the da e day. <i>Turn to j</i>	ay. What does	s this mean to
Self-disco you and wr	very Journey: ite about how y	Wake up and	d seize the da e day. <i>Turn to j</i>	ay. What does	s this mean to
Self-disco you and wr	very Journey: ite about how y	Wake up and	d seize the da e day. <i>Turn to j</i>	ay. What does	s this mean to
Self-disco you and wr	very Journey: ite about how y	Wake up and	d seize the da e day. <i>Turn to j</i>	ay. What does	s this mean to
Self-disco you and wr	very Journey: ite about how y	Wake up and	d seize the da e day. <i>Turn to j</i>	ay. What does	s this mean to
Self-disco you and wr	very Journey: ite about how y	Wake up and	d seize the da e day. <i>Turn to j</i>	ay. What does	s this mean to
Self-disco you and wr	very Journey: ite about how y	Wake up and	d seize the da e day. <i>Turn to j</i>	ay. What does	s this mean to
Self-disco you and wr	very Journey: ite about how y	Wake up and	d seize the da e day. <i>Turn to j</i>	ay. What does	s this mean to
Self-disco you and wr	very Journey: ite about how y	Wake up and	d seize the da e day. <i>Turn to j</i>	ay. What does	s this mean to

	Writing a New Chapter Journey: How do you feel when you make a mistake? Do you feel worse if it's a mistake at work or in your personal life? <i>Turn to page 64</i>	
_		
	Mending Fences Journey: Practice the art of forgiveness. Don't hold grudges. How easy is it for you to forgive others? <i>Turn to page 64</i>	

Self-improve devoted to ex Turn to page 65	ploring and learning	g more about y	ourself. What v	vill you do firs	st?
Spiritual Jou	ı rney: What type of	f energy do you	ı attract and w	ny do you thi	nk ye
Spiritual Jou attract this en	urney: What type of ergy. How can you a	f energy do you attract more of	ı attract and w what you want	ny do you thi to you? <i>Turn</i>	nk yo
Spiritual Jou attract this en	urney: What type of ergy. How can you a	f energy do you attract more of	ı attract and wi what you wani	ny do you thi to you? <i>Turn</i>	nk yo
Spiritual Jou attract this en	urney: What type of ergy. How can you a	f energy do you attract more of	ı attract and wi what you wan!	ny do you thi to you? <i>Turn</i>	nk yo
Spiritual Jou attract this en	urney: What type of ergy. How can you a	f energy do you attract more of	ı attract and wi what you wan!	ny do you thi to you? <i>Turn</i>	nk yo
Spiritual Jou attract this en	urney: What type of ergy. How can you a	f energy do you attract more of	ı attract and w what you wan!	ny do you thi to you? <i>Turn</i>	nk yo
Spiritual Jou attract this en	urney: What type of ergy. How can you a	f energy do you attract more of	ı attract and wi what you want	ny do you thi to you? <i>Turn</i>	nk yo
Spiritual Jou attract this en	u rney: What type of ergy. How can you a	f energy do you attract more of	ı attract and wi what you want	ny do you thi to you? <i>Turn</i>	nk ye
Spiritual Jou attract this en	urney: What type of ergy. How can you a	f energy do you attract more of	ı attract and wi what you want	ny do you thi to you? <i>Turn</i>	nk yo
Spiritual Jou attract this en	urney: What type of ergy. How can you a	f energy do you attract more of	ı attract and w what you want	ny do you thi to you? <i>Turn</i>	nk yv
Spiritual Jou attract this en	urney: What type of ergy. How can you a	f energy do you attract more of	ı attract and w what you want	ny do you thi to you? <i>Turn</i>	nk yo
Spiritual Jou attract this en	urney: What type of ergy. How can you a	f energy do you attract more of	ı attract and w what you want	ny do you thi to you? <i>Turn</i>	nk yo
Spiritual Jou attract this en	urney: What type of ergy. How can you a	f energy do you attract more of	ı attract and w what you want	ny do you thi to you? <i>Turn</i>	nk yo
Spiritual Jou attract this en	urney: What type of ergy. How can you a	f energy do you attract more of	ı attract and w what you want	ny do you thi to you? <i>Turn</i>	nk yv
Spiritual Jou attract this en	urney: What type of ergy. How can you a	f energy do you attract more of	ı attract and w what you want	ny do you thi to you? <i>Turn</i>	nk yv
Spiritual Jou attract this en	urney: What type of ergy. How can you a	f energy do you attract more of	ı attract and wi what you want	ny do you thi to you? <i>Turn</i>	nk yo
Spiritual Jou attract this en	urney: What type of ergy. How can you a	f energy do you attract more of	ı attract and w what you want	ny do you thi to you? <i>Turn</i>	nk yo
Spiritual Jou attract this en	urney: What type of ergy. How can you a	f energy do you attract more of	ı attract and w what you want	ny do you thi to you? <i>Turn</i>	nk yo
Spiritual Jou attract this en	urney: What type of ergy. How can you a	f energy do you attract more of	ı attract and w what you want	ny do you thi to you? <i>Turn</i>	nk yo
Spiritual Jou attract this en	urney: What type of ergy. How can you a	f energy do you attract more of	ı attract and w what you wan!	ny do you thi to you? <i>Turn</i>	nk yo
Spiritual Jou attract this en	urney: What type of ergy. How can you a	f energy do you attract more of	ı attract and w what you want	ny do you thi to you? <i>Turn</i>	nk yo

	n Journey: How important is money to you and how does it influence em your life's calling or purpose to be? <i>Turn to page 66</i>
Humanitar How did it fe	rian Journey: What's the nicest thing you've ever done for someone?
Humanitar How did it fe	rian Journey: What's the nicest thing you've ever done for someone? eel? Turn to page 66
Humanitar How did it fe	rian Journey: What's the nicest thing you've ever done for someone? eel? Turn to page 66
Humanitar How did it fe	rian Journey: What's the nicest thing you've ever done for someone?
Humanitan How did it fe	rian Journey: What's the nicest thing you've ever done for someone? eel? Turn to page 66
Humanitar How did it fe	rian Journey: What's the nicest thing you've ever done for someone? eel? Turn to page 66
Humanitar How did it fe	rian Journey: What's the nicest thing you've ever done for someone? eel? Turn to page 66
Humanitan How did it fe	rian Journey: What's the nicest thing you've ever done for someone? eel? Turn to page 66
Humanitan How did it fe	rian Journey: What's the nicest thing you've ever done for someone? eel? Turn to page 66
Humanitan	rian Journey: What's the nicest thing you've ever done for someone? eel? Turn to page 66
Humanitan	rian Journey: What's the nicest thing you've ever done for someone? eel? Turn to page 66
Humanitan	rian Journey: What's the nicest thing you've ever done for someone? eel? Turn to page 66

	overcome your fear/s? Turn to page 67	
1	Chaotic Resolve Journey: Do you get enough sleep? Evaluate your sleep habits and look for ways to improve your sleep. Write about habits you need to	
1	habits and look for ways to improve your sleep. Write about habits you need to change. <i>Turn to page 67</i>	
1	habits and look for ways to improve your sleep. Write about habits you need to	
1	habits and look for ways to improve your sleep. Write about habits you need to	
1	habits and look for ways to improve your sleep. Write about habits you need to	
1	habits and look for ways to improve your sleep. Write about habits you need to	
1	habits and look for ways to improve your sleep. Write about habits you need to	
1	habits and look for ways to improve your sleep. Write about habits you need to	
1	habits and look for ways to improve your sleep. Write about habits you need to	
1	habits and look for ways to improve your sleep. Write about habits you need to	
1	habits and look for ways to improve your sleep. Write about habits you need to	
1	habits and look for ways to improve your sleep. Write about habits you need to	
1	habits and look for ways to improve your sleep. Write about habits you need to	
1	habits and look for ways to improve your sleep. Write about habits you need to	
1	habits and look for ways to improve your sleep. Write about habits you need to	

favorite w	nent Journey: Make the most of each day and don't forget to schedule relax. Write about how you can make better use of each day and your ays to relax. <i>Turn to page</i> 68	
Salf_disc	overy Tourney Loarn a now language What language speaks to you	
Self-disc and why?	overy Journey: Learn a new language. What language speaks to you Turn to page 68	
Self-discand why?	overy Journey: Learn a new language. What language speaks to you Turn to page 68	
Self-disc and why?	overy Journey: Learn a new language. What language speaks to you Turn to page 68	
Self-disc and why?	overy Journey: Learn a new language. What language speaks to you Turn to page 68	
Self-disc and why?	overy Journey: Learn a new language. What language speaks to you Turn to page 68	
Self-disc and why?	overy Journey: Learn a new language. What language speaks to you Turn to page 68	
Self-disc and why?	overy Journey: Learn a new language. What language speaks to you Turn to page 68	
Self-disc and why?	overy Journey: Learn a new language. What language speaks to you Turn to page 68	
Self-disc and why?	overy Journey: Learn a new language. What language speaks to you Turn to page 68	
Self-disc and why?	overy Journey: Learn a new language. What language speaks to you Turn to page 68	

there c	ly specific mistake you	navonitinado pod	cope with most mistakes? Is ce with yet? <i>Turn to page 69</i>
Mend	ng Fences Journey: H	ave you ever burne how can vou repair	ed a bridge and later regretted
Mend it? Who	ng Fences Journey: H	ave you ever burne how can you repair	ed a bridge and later regretted this bridge? <i>Turn to page 69</i>
Mend it? Who	ng Fences Journey: H	ave you ever burne how can you repair	ed a bridge and later regretted this bridge? <i>Turn to page</i> 69
Mend it? Who	ng Fences Journey: H	ave you ever burne how can you repair	ed a bridge and later regretted this bridge? <i>Turn to page</i> 69
Mend it? Who	ng Fences Journey: Hand did you burn with and	ave you ever burne how can you repair	ed a bridge and later regretted this bridge? <i>Turn to page 69</i>
Mend it? Who	ng Fences Journey: H	ave you ever burne how can you repair	ed a bridge and later regretted this bridge? <i>Turn to page 69</i>
Mend it? Who	ng Fences Journey: H	ave you ever burne how can you repair	ed a bridge and later regretted this bridge? <i>Turn to page 69</i>
Mend it? Who	ng Fences Journey: H	ave you ever burne how can you repair	ed a bridge and later regretted this bridge? <i>Turn to page 69</i>
Mend it? Who	ng Fences Journey: H	ave you ever burne how can you repair	ed a bridge and later regretted this bridge? <i>Turn to page 69</i>
Mend it? Who	ng Fences Journey: H	ave you ever burne how can you repair	ed a bridge and later regretted this bridge? Turn to page 69
Mend it? Who	ng Fences Journey: H	ave you ever burne how can you repair	ed a bridge and later regretted this bridge? Turn to page 69
Mend it? Who	ng Fences Journey: H	ave you ever burne how can you repair	ed a bridge and later regretted this bridge? Turn to page 69
Mend it? Who	ng Fences Journey: H	ave you ever burne how can you repair	ed a bridge and later regretted this bridge? Turn to page 69
Mend it? Who	ng Fences Journey: H	ave you ever burne how can you repair	ed a bridge and later regretted this bridge? Turn to page 69
Mend it? Who	ng Fences Journey: H	ave you ever burne how can you repair	ed a bridge and later regretted this bridge? Turn to page 69
Mend it? Who	ng Fences Journey: H	ave you ever burne how can you repair	ed a bridge and later regretted this bridge? Turn to page 69

	You've seen them all over social media, find one you like and accept the e. Write about the challenge you're going to try. <i>Turn to page 70</i>
1	, , , and the second and the wind the second and the wind the second and the seco
our curr	l Journey: Do you believe in karma? What is your definition and how is ent karma? <i>Turn to page 70</i>
our curr	ent karma? Turn to page 70
our curr	ent karma? Turn to page 70
our curr	ent karma? Turn to page 70
our curr	ent karma? Turn to page 70
our curr	ent karma? Turn to page 70
our curr	ent karma? Turn to page 70
our curr	ent karma? Turn to page 70
our curr	ent karma? Turn to page 70
our curr	ent karma? Turn to page 70
our curr	ent karma? Turn to page 70

Destinatio any) do you	want to start and h	ow will this impact you	1 0
Humanita:	rian Journey: Stay	positive an entire day,	, from start to finish. No our day and how it felt to st
negative thi	nking, speaking or	positive an entire day, actions. Write about yo day better? <i>Turn to page</i>	our day and how it felt to st
negative thi	nking, speaking or	actions. Write about yo	our day and how it felt to st
negative thi	nking, speaking or	actions. Write about yo	our day and how it felt to st
negative thi	nking, speaking or	actions. Write about yo	our day and how it felt to st
negative thi	nking, speaking or	actions. Write about yo	our day and how it felt to st
negative thi	nking, speaking or	actions. Write about yo	our day and how it felt to st
negative thi	nking, speaking or	actions. Write about yo	our day and how it felt to st
negative thi	nking, speaking or	actions. Write about yo	our day and how it felt to st
negative thi	nking, speaking or	actions. Write about yo	our day and how it felt to st
negative thi	nking, speaking or	actions. Write about yo	our day and how it felt to st
negative thi	nking, speaking or	actions. Write about yo	our day and how it felt to st
negative thi	nking, speaking or	actions. Write about yo	our day and how it felt to st
negative thi	nking, speaking or	actions. Write about yo	our day and how it felt to st
negative thi	nking, speaking or	actions. Write about yo	our day and how it felt to st
negative thi	nking, speaking or	actions. Write about yo	our day and how it felt to st

Overcomer's Journey: Have you tried something spiritual like praying when you're afraid? Write about how spirituality or prayer impacts your fears. <i>Turn to page 72</i>
Chaotic Resolve Journey: Is there someone in your life you haven't forgiven? Forgive them and move on. Write about how forgiveness makes you feel. <i>Turn to page 72</i>

	out your favorite ways to reward yourself. Turn to page 73
	,
	,
Wh	If-discovery Journey: Think back to your childhood, what made you happy hat did you enjoy doing and how has that changed as you've gotten older? ite about how you're still similar to your younger self. <i>Turn to page 73</i>

	petter care of yourself. Turn to page 74	
ould like to b	nces Journey: A golden rule to live by is, "treat others how you be treated." Do you live by these words? Create your own golder and start implementing them into your life. Turn to page 74	n
ould like to b	be treated." Do you live by these words? Create your own golder	1
ould like to b	be treated." Do you live by these words? Create your own golder	1
ould like to b	be treated." Do you live by these words? Create your own golder	1
ould like to b	be treated." Do you live by these words? Create your own golder	n
ould like to b	be treated." Do you live by these words? Create your own golder	ר
ould like to b	be treated." Do you live by these words? Create your own golder	n
ould like to b	be treated." Do you live by these words? Create your own golder	n
ould like to b	be treated." Do you live by these words? Create your own golder	n
ould like to b	be treated." Do you live by these words? Create your own golder	1
ould like to b	be treated." Do you live by these words? Create your own golder	n

Self-improveme the whole staircas page 75	e, just take the fir	si siep. Whai	. Si louta your	nrst step b	e? Turn
	,				
					9 1
				, , , , , , , , , , , , , , , , , , ,	
Spiritual Journe how you came to	y: Do you recogn this reality? <i>Turn t</i> e	iize your creat o page 75	or? Describe	your create	or and
Spiritual Journe how you came to	y: Do you recogn this reality? <i>Turn t</i> e	iize your creat o page 75	or? Describe	your create	or and
Spiritual Journe how you came to	y: Do you recogn this reality? <i>Turn t</i> e	iize your creat o page 75	or? Describe	your create	or and
Spiritual Journe how you came to	y: Do you recogn this reality? <i>Turn t</i> e	nize your creat o page 75	or? Describe	your create	or and
Spiritual Journe how you came to	y: Do you recogn this reality? <i>Turn t</i>	nize your creat o page 75	or? Describe	your create	or and
Spiritual Journe; how you came to	y: Do you recogn this reality? <i>Turn t</i>	nize your creat o page 75	or? Describe	your create	or and
Spiritual Journe; how you came to	y: Do you recogn this reality? <i>Turn t</i>	nize your creat	or? Describe	your create	or and
Spiritual Journe how you came to	y: Do you recogn this reality? <i>Turn to</i>	nize your creat	or? Describe	your create	or and
Spiritual Journe how you came to	y: Do you recogn this reality? <i>Turn to</i>	iize your creat	or? Describe	your create	or and
Spiritual Journe how you came to	y: Do you recogn this reality? <i>Turn t</i>	nize your creat	or? Describe	your create	or and

		8			
Iumanitai	rian Journey	y: What kind of	mentor do you	think you'd be? \	What's the
Humanita est advice	rian Journey you'll give so	y: What kind of omeone you're	mentor do you mentoring? <i>Turn</i>	think you'd be? \ n to page 76	What's the
Humanitai est advice	rian Journey you'll give so	y: What kind of omeone you're	mentor do you mentoring? <i>Turn</i>	think you'd be? \ n to page 76	What's the
Humanita est advice	rian Journey you'll give so	y: What kind of omeone you're	mentor do you mentoring? <i>Turn</i>	think you'd be? \ n to page 76	What's the
Iumanitai est advice	rian Journey you'll give sc	y: What kind of omeone you're	mentor do you mentoring? <i>Turn</i>	think you'd be? \ n to page 76	What's the
Humanita est advice	rian Journey you'll give so	y: What kind of omeone you're	mentor do you mentoring? <i>Turn</i>	think you'd be? \ n to page 76	What's the
Iumanita est advice	rian Journey you'll give so	y: What kind of omeone you're	mentor do you mentoring? <i>Turn</i>	think you'd be? \ n to page 76	What's the
Iumanitai est advice	rian Journey you'll give so	y: What kind of omeone you're	mentor do you mentoring? <i>Turn</i>	think you'd be? \ n to page 76	What's the
Jumanita est advice	rian Journey you'll give so	y: What kind of omeone you're	mentor do you mentoring? <i>Turn</i>	think you'd be? \ n to page 76	What's the
Jumanita est advice	rian Journey you'll give so	y: What kind of omeone you're	mentor do you mentoring? <i>Turn</i>	think you'd be? \	What's the
Humanita est advice	rian Journey you'll give so	y: What kind of omeone you're	mentor do you mentoring? <i>Turn</i>	think you'd be? \	What's the
Iumanita est advice	rian Journey you'll give so	y: What kind of omeone you're	mentor do you mentoring? <i>Turn</i>	think you'd be? \	What's the
Humanitai est advice	rian Journey you'll give so	y: What kind of omeone you're	mentor do you mentoring? <i>Turn</i>	think you'd be? \	What's the
Humanita est advice	rian Journey you'll give so	y: What kind of omeone you're	mentor do you mentoring? <i>Turn</i>	think you'd be? \	What's the
Humanita est advice	rian Journey you'll give so	y: What kind of omeone you're	mentor do you mentoring? <i>Turn</i>	think you'd be? \	What's the

ok	haotic Resolve Journey: When you hear the word "peace" what images or jects come to mind? Write down all the things or images you think of that
ok	haotic Resolve Journey: When you hear the word "peace" what images or jects come to mind? Write down all the things or images you think of that oke a spirit of peace within you. <i>Turn to page 77</i>
ob	jects come to mind? Write down all the things or images you think of that
ob	jects come to mind? Write down all the things or images you think of that
ob	jects come to mind? Write down all the things or images you think of that
ob	jects come to mind? Write down all the things or images you think of that
ob	jects come to mind? Write down all the things or images you think of that
ok	jects come to mind? Write down all the things or images you think of that
ok	jects come to mind? Write down all the things or images you think of that
ok	jects come to mind? Write down all the things or images you think of that
ok	jects come to mind? Write down all the things or images you think of that
ob	jects come to mind? Write down all the things or images you think of that
ob	jects come to mind? Write down all the things or images you think of that
ob	jects come to mind? Write down all the things or images you think of that
ob	jects come to mind? Write down all the things or images you think of that
ob	jects come to mind? Write down all the things or images you think of that
ob	jects come to mind? Write down all the things or images you think of that
ob	jects come to mind? Write down all the things or images you think of that
ob	jects come to mind? Write down all the things or images you think of that
ok	jects come to mind? Write down all the things or images you think of that

nake and wha	t will be the harde	ng to sacrifice. Son s. What sacrifices d st sacrifice? <i>Turn to</i>	io you think you w page 78	ill have to
16. 1.	•			
lf-discovery ving enough	Journey: At the time to do? Turn to	end of your life, wh	nat would you regi	ret not
lf-discovery ving enough	Journey: At the time to do? Turn to	end of your life, wh	nat would you regi	ret not
lf-discovery ving enough	Journey: At the time to do? <i>Turn to</i>	end of your life, wh	nat would you regi	ret not
lf-discovery ving enough	Journey: At the time to do? Turn to	end of your life, wh	nat would you regi	ret not
lf-discovery ving enough	Journey: At the time to do? Turn to	end of your life, wh	nat would you regi	ret not
lf-discovery ving enough	Journey: At the time to do? Turn to	end of your life, wh	nat would you regi	ret not
lf-discovery /ing enough	Journey: At the time to do? Turn to	end of your life, wh	nat would you regi	ret not
lf-discovery /ing enough	Journey: At the time to do? Turn to	end of your life, wh	nat would you regi	ret not
If-discovery ving enough	Journey: At the time to do? Turn to	end of your life, wh	nat would you regi	ret not
lf-discovery /ing enough	Journey: At the time to do? Turn to	end of your life, wh	nat would you regi	ret not
If-discovery /ing enough	Journey: At the time to do? Turn to	end of your life, wh	nat would you regi	ret not

p	that's going on and mature. Describe the silver lining in your last mistake. <i>Turn to</i> age 79
_	
_	
I	Mending Fences Journey: Have you ever taken credit for something that
٧	Mending Fences Journey: Have you ever taken credit for something that wasn't yours or stolen something from someone? Explain the situation and how ended. Turn to page 79
٧	vasn't yours or stolen something from someone? Explain the situation and how
٧	vasn't yours or stolen something from someone? Explain the situation and how i
٧	vasn't yours or stolen something from someone? Explain the situation and how i
٧	vasn't yours or stolen something from someone? Explain the situation and how i
٧	vasn't yours or stolen something from someone? Explain the situation and how i
٧	vasn't yours or stolen something from someone? Explain the situation and how i
٧	vasn't yours or stolen something from someone? Explain the situation and how i
٧	vasn't yours or stolen something from someone? Explain the situation and how i
٧	vasn't yours or stolen something from someone? Explain the situation and how
٧	vasn't yours or stolen something from someone? Explain the situation and how i
٧	vasn't yours or stolen something from someone? Explain the situation and how i

		,				16 120
piritual Journ	ı ey: Does your s	oirituality ha	ve a direct c	onnection	to your	
piritual Jourr appiness? Writ	n ey: Does your speed about the link l	oirituality ha	ve a direct c	onnection bage 80	to your	
piritual Jourr appiness? Writ	l ey: Does your speed about the link l	oirituality ha	ve a direct c	onnection page 80	to your	
piritual Jourr appiness? Writ	ley: Does your s _l e about the link l	oirituality ha between the	ve a direct c	onnection page 80	to your	
piritual Jourr appiness? Writ	ley: Does your speed about the link I	oirituality ha between the	ve a direct c	onnection bage 80	to your	
piritual Jourr appiness? Writ	ley: Does your s _l e about the link l	oirituality ha	ve a direct c	onnection page 80	to your	
piritual Jourr appiness? Writ	ley: Does your speabout the link b	oirituality ha	ve a direct c	onnection page 80	to your	
piritual Journ appiness? Writ	ley: Does your speed about the link been speed to be about t	oirituality ha	ve a direct c	onnection page 80	to your	
piritual Journ appiness? Writ	ley: Does your speed about the link l	oirituality ha between the	ve a direct c	onnection page 80	to your	
piritual Journ appiness? Writ	ley: Does your speed about the link l	oirituality ha	ve a direct c	onnection bage 80	to your	
piritual Journ appiness? Writ	ley: Does your spee about the link l	pirituality ha	ve a direct c	onnection bage 80	to your	
piritual Journ appiness? Writ	ley: Does your spee about the link l	pirituality ha	ve a direct c	onnection bage 80	to your	
piritual Journ appiness? Writ	ey: Does your spee about the link I	pirituality ha	ve a direct c	onnection bage 80	to your	
piritual Journ appiness? Writ	ey: Does your speaked about the link I	pirituality ha	ve a direct c	onnection bage 80	to your	
piritual Journ appiness? Writ	ey: Does your spee about the link i	pirituality ha	ve a direct c	onnection page 80	to your	
Spiritual Journ appiness? Writ	ey: Does your spee about the link i	pirituality ha	ve a direct c	onnection page 80	to your	
piritual Journ appiness? Writ	ey: Does your speaked about the link b	pirituality ha	ve a direct co	onnection page 80	to your	
piritual Journ	ey: Does your speabout the link b	pirituality ha	ve a direct co	onnection page 80	to your	

your soul				,		
Humani	itarian Journ	ney: Write ab	oout how you	can help out	in your own	
commun	itarian Journ ity. What doe e? Turn to page 8	s your comm	oout how you nunity need a	can help out nd how can y	in your own ou make a	
commun	ity. What doe	s your comm	oout how you nunity need a	can help out nd how can y	in your own ou make a	
commun	ity. What doe	s your comm	oout how you nunity need a	can help out nd how can y	in your own ou make a	
commun	ity. What doe	s your comm	oout how you nunity need a	can help out nd how can y	in your own ou make a	
commun	ity. What doe	s your comm	oout how you nunity need a	can help out nd how can y	in your own ou make a	
commun	ity. What doe	s your comm	oout how you nunity need a	can help out nd how can y	in your own ou make a	
commun	ity. What doe	s your comm	oout how you nunity need a	can help out nd how can y	in your own ou make a	
commun	ity. What doe	s your comm	oout how you nunity need a	can help out nd how can y	in your own ou make a	
commun	ity. What doe	s your comm	oout how you nunity need a	can help out nd how can y	in your own ou make a	
commun	ity. What doe	s your comm	oout how you nunity need a	can help out nd how can y	in your own ou make a	
commun	ity. What doe	s your comm	oout how you nunity need a	can help out nd how can y	in your own ou make a	
commun	ity. What doe	s your comm	oout how you nunity need a	can help out nd how can y	in your own ou make a	
commun	ity. What doe	s your comm	oout how you nunity need a	can help out nd how can y	in your own ou make a	
commun	ity. What doe	s your comm	oout how you nunity need a	can help out nd how can y	in your own ou make a	
commun	ity. What doe	s your comm	oout how you nunity need a	can help out nd how can y	in your own ou make a	
commun	ity. What doe	s your comm	oout how you nunity need a	can help out nd how can y	in your own ou make a	

)vercomer's Journey: Help a friend try and overcome a fear they have. Nout the details. <i>Turn to page 82</i>	
Chaotic Resolve Journey: Where is your place of serenity and why does nake you feel this way? <i>Turn to page 82</i>	it

hold yours					
C 1C 1:	Ţ	NV (I I			Caral all and m
Self-disco	overy Journey	: What gets yo	u excited and	d makes you	feel alive? Turn
Self-disco	overy Journey	: What gets yo	u excited and	d makes you	feel alive? Turn
Self-disco	overy Journey:	: What gets yo	u excited and	d makes you	feel alive? Turn
Self-disco	overy Journey	: What gets yo	u excited and	d makes you	feel alive? <i>Turn</i>
Self-disco	overy Journey	: What gets yo	u excited and	d makes you	feel alive? Turn
Self-disco to page 83	overy Journey	: What gets yo	u excited and	d makes you	feel alive? Turn
Self-disco	overy Journey:	: What gets yo	u excited and	d makes you	feel alive? Turn
Self-disco	overy Journey	: What gets yo	u excited and	d makes you	feel alive? Turn
Self-disco	overy Journey	: What gets yo	u excited and	d makes you	feel alive? Turn
Self-disco	overy Journey	: What gets yo	u excited and	d makes you	feel alive? Turn
Self-disco	overy Journey	: What gets yo	u excited and	d makes you	feel alive? Turn
Self-disco	overy Journey	: What gets yo	u excited and	d makes you	feel alive? Turn
Self-disco	overy Journey	: What gets yo	u excited and	d makes you	feel alive? Turn
Self-disco	overy Journey	: What gets yo	u excited and	d makes you	feel alive? Turn
Self-disco	overy Journey	: What gets yo	u excited and	d makes you	feel alive? Turn
Self-disco	overy Journey	: What gets yo	u excited and	d makes you	feel alive? Turn
Self-disco	overy Journey	: What gets yo	u excited and	d makes you	feel alive? Turn

X	Writing a New Chapter Journey: Reshape your goals. Use what you've arned from past mistakes to reshape and redefine what you want from life. That is one of your goals that needs reshaping? Turn to page 84
N sh	lending Fences Journey: Practice compassion. Write about ways you can
	now compassion to others and a plan to put it into motion. Turn to page 84
	now compassion to others and a plan to put it into motion. Turn to page 84
	now compassion to others and a plan to put it into motion. Turn to page 84
	now compassion to others and a plan to put it into motion. Turn to page 84
	now compassion to others and a plan to put it into motion. Turn to page 84
	now compassion to others and a plan to put it into motion. Turn to page 84
	now compassion to others and a plan to put it into motion. Turn to page 84
	now compassion to others and a plan to put it into motion. Turn to page 84

why you				1 0		
Spiritua about yo	al Journey: our most me	: Do you go t emorable exp	o church? Ho	ow do you fee hurch. <i>Turn to</i>	el about churc	ch? Write
Spiritu a about yo	al Journey: our most me	: Do you go t emorable exp	o church? Ho perience at c	ow do you fee hurch. <i>Turn to j</i>	el about churc page 85	ch? Write
Spiritu : about yo	al Journey: our most me	: Do you go t emorable exp	o church? Ho perience at c	ow do you fee hurch. <i>Turn to</i>	el about churc page 85	ch? Write
Spiritu : about yo	al Journey: bur most me	: Do you go t emorable exp	o church? Ho perience at c	ow do you fee hurch. <i>Turn to</i>	el about churc page 85	ch? Write
Spiritu : about yo	al Journey: our most me	: Do you go t emorable exp	o church? Ho perience at c	ow do you fee hurch. <i>Turn to</i>	el about churc	ch? Write
Spiritu : about yo	al Journey: our most me	: Do you go t emorable exp	o church? Ho perience at c	ow do you fee hurch. <i>Turn to</i>	el about churc page 85	ch? Write
Spiritu a about yo	al Journey: our most me	: Do you go t emorable exp	o church? Ho perience at c	ow do you fee hurch. <i>Turn to j</i>	el about churc	ch? Write
Spiritu : about yo	al Journey: our most me	: Do you go t emorable ex	o church? Ho perience at c	ow do you fee hurch. <i>Turn to</i>	el about churc page 85	ch? Write
Spiritu:	al Journey: our most me	: Do you go t emorable exp	o church? Ho perience at c	ow do you fee hurch. <i>Turn to</i>	el about churc	ch? Write
Spiritua about yo	al Journey: our most me	: Do you go t emorable exp	o church? Ho perience at c	ow do you fee hurch. <i>Turn to</i>	el about churc	ch? Write
Spiritu:	al Journey: our most me	: Do you go t emorable exp	o church? Ho perience at c	ow do you fee hurch. <i>Turn to</i>	el about churc	ch? Write
Spiritu:	al Journey: our most me	: Do you go t emorable exp	o church? Ho perience at c	ow do you fee hurch. <i>Turn to</i>	el about churc	ch? Write
Spiritu:	al Journey: our most me	: Do you go t emorable exp	o church? Ho perience at c	ow do you fee hurch. <i>Turn to</i>	el about churc	ch? Write
Spiritua about yo	al Journey: our most me	: Do you go t emorable exp	o church? Ho perience at c	ow do you fee hurch. <i>Turn to</i>	el about churc	ch? Write
Spiritu:	al Journey: our most me	: Do you go t emorable exp	o church? Ho perience at c	ow do you fee hurch. <i>Turn to</i>	el about churc	ch? Write
Spiritu:	al Journey: our most me	: Do you go t emorable exp	o church? Ho perience at c	ow do you fee hurch. <i>Turn to</i>	el about churc	ch? Write
Spiritu:	al Journey: our most me	: Do you go t emorable exp	o church? Ho perience at c	ow do you fee hurch. <i>Turn to</i>	el about churc	ch? Write
Spiritua about yo	al Journey: bur most me	: Do you go t emorable exp	o church? Ho perience at c	ow do you fee hurch. <i>Turn to</i>	el about churc	ch? Write

you love or think you would watching the documentaries	ch a documentary online about the top 3 professions be good at. Write about what you learned after S. <i>Turn to page 86</i>
	,
Humanitarian Journey: Hablood drive? Do you think it's awareness? Turn to page 86	ave you ever donated blood or been a part of a s important to donate blood and how can you raise

n	bout the future or things beyond your control. Read about the principles of nindfulness and start applying them to your life. Write about if you think it will lelp you. <i>Turn to page 87</i>

Achievement Journey: Don't allow bumps in the road or setbacks to derail your journey or focus. There will always be challenges in anything you do but the key is to keep moving forward. What are some of the toughest challenges you've faced and what could you have done better? <i>Turn to page 88</i>	
Self-discovery Journey: If money was not an issue, how would you spend your time? <i>Turn to page 88</i>	

bee	nding Fences Journey: Have you ever taken advantage of someone or in taken advantage of? What did you do and how did the other person reac
Wha	at did you learn from this? <i>Turn to page 89</i>
Wha	at did you learn from this? <i>Turn to page 89</i>
Wha	at did you learn from this? <i>Turn to page 89</i>
Wha	at did you learn from this? Turn to page 89
Wha	at did you learn from this? Turn to page 89
Wha	at did you learn from this? Turn to page 89
Wha	at did you learn from this? Turn to page 89
Wha	at did you learn from this? Turn to page 89
Wha	at did you learn from this? Turn to page 89
Wha	at did you learn from this? Turn to page 89
Wha	at did you learn from this? Turn to page 89
Wha	at did you learn from this? Turn to page 89
Wha	at did you learn from this? Turn to page 89
Wha	at did you learn from this? Turn to page 89
Wha	at did you learn from this? Turn to page 89
Wha	at did you learn from this? Turn to page 89
Wha	at did you learn from this? Turn to page 89

Spiritual Journey: Describe what you think a soul is and then write about your very own soul. Turn to page 90
Spiritual Journey: Describe what you think a soul is and then write about your very own soul. Turn to page 90
Spiritual Journey: Describe what you think a soul is and then write about your very own soul. Turn to page 90
Spiritual Journey: Describe what you think a soul is and then write about your very own soul. Turn to page 90
Spiritual Journey: Describe what you think a soul is and then write about your very own soul. Turn to page 90
Spiritual Journey: Describe what you think a soul is and then write about your very own soul. <i>Turn to page 90</i>
Spiritual Journey: Describe what you think a soul is and then write about your very own soul. <i>Turn to page 90</i>
Spiritual Journey: Describe what you think a soul is and then write about your very own soul. <i>Turn to page 90</i>
Spiritual Journey: Describe what you think a soul is and then write about your very own soul. <i>Turn to page 90</i>
Spiritual Journey: Describe what you think a soul is and then write about your very own soul. <i>Turn to page 90</i>
Spiritual Journey: Describe what you think a soul is and then write about your very own soul. <i>Turn to page 90</i>

(or accomplish and why? Turn to page 91
_	
-	
it	and write a thoughtful post, share it to your social media. Tell others how they
it	and write a thoughtful post, share it to your social media. Tell others how they
it	and write a thoughtful post, share it to your social media. Tell others how they an help and get involved. Write about the kind of response you received. <i>Turn t</i>
it	and write a thoughtful post, share it to your social media. Tell others how they an help and get involved. Write about the kind of response you received. <i>Turn t</i>
it	and write a thoughtful post, share it to your social media. Tell others how they an help and get involved. Write about the kind of response you received. <i>Turn t</i>
it	and write a thoughtful post, share it to your social media. Tell others how they an help and get involved. Write about the kind of response you received. <i>Turn t</i>
it	and write a thoughtful post, share it to your social media. Tell others how they an help and get involved. Write about the kind of response you received. <i>Turn t</i> e
it	and write a thoughtful post, share it to your social media. Tell others how they an help and get involved. Write about the kind of response you received. <i>Turn t</i> e
it	and write a thoughtful post, share it to your social media. Tell others how they an help and get involved. Write about the kind of response you received. <i>Turn t</i> e
it	and write a thoughtful post, share it to your social media. Tell others how they an help and get involved. Write about the kind of response you received. <i>Turn t</i>
it	and write a thoughtful post, share it to your social media. Tell others how they an help and get involved. Write about the kind of response you received. <i>Turn t</i>
it	and write a thoughtful post, share it to your social media. Tell others how they an help and get involved. Write about the kind of response you received. <i>Turn t</i>
it	and write a thoughtful post, share it to your social media. Tell others how they an help and get involved. Write about the kind of response you received. <i>Turn t</i>
it	and write a thoughtful post, share it to your social media. Tell others how they an help and get involved. Write about the kind of response you received. <i>Turn t</i>
it	and write a thoughtful post, share it to your social media. Tell others how they an help and get involved. Write about the kind of response you received. <i>Turn t</i>
it	and write a thoughtful post, share it to your social media. Tell others how they an help and get involved. Write about the kind of response you received. <i>Turn t</i>
it	and write a thoughtful post, share it to your social media. Tell others how they an help and get involved. Write about the kind of response you received. <i>Turn t</i>
it	an help and get involved. Write about the kind of response you received. Turn to

this particular	dentify some triggers that activate that fear. Determine your level r fear. Write about your discovery. <i>Turn to page 92</i>
Chaotic Resol ow can you st age 92	Ive Journey: What places cause you stress or steal your peace? top allowing these places to have a negative effect on you? <i>Turn to</i>
	· · · · · · · · · · · · · · · · · · ·

15.		
Self-discove	ery Journey: What changes would y	ou like to see in the world and
Self-discove how can you	ery Journey: What changes would y contribute to those changes? Turn to	ou like to see in the world and page 93
Self-discove how can you	ery Journey: What changes would y contribute to those changes? <i>Turn to</i>	ou like to see in the world and page 93
Self-discove how can you	ery Journey: What changes would y contribute to those changes? <i>Turn to</i>	ou like to see in the world and page 93
Self-discove how can you	ery Journey: What changes would y contribute to those changes? <i>Turn to</i>	rou like to see in the world and page 93
Self-discove how can you	ery Journey: What changes would y contribute to those changes? <i>Turn to</i>	ou like to see in the world and page 93
Self-discove how can you	ery Journey: What changes would y contribute to those changes? <i>Turn to</i>	rou like to see in the world and page 93
Self-discove how can you	ery Journey: What changes would y contribute to those changes? <i>Turn to</i>	you like to see in the world and page 93
Self-discove how can you	ery Journey: What changes would y contribute to those changes? <i>Turn to</i>	you like to see in the world and page 93
Self-discove how can you	ery Journey: What changes would y contribute to those changes? <i>Turn to</i>	ou like to see in the world and page 93
Self-discove how can you	ery Journey: What changes would y contribute to those changes? <i>Turn to</i>	ou like to see in the world and page 93
Self-discove how can you	ery Journey: What changes would y contribute to those changes? Turn to	ou like to see in the world and page 93
Self-discove how can you	ery Journey: What changes would y contribute to those changes? <i>Turn to</i>	ou like to see in the world and page 93
Self-discove how can you	ery Journey: What changes would y contribute to those changes? <i>Turn to</i>	you like to see in the world and page 93
Self-discove how can you	ery Journey: What changes would y	you like to see in the world and page 93
Self-discove how can you	ery Journey: What changes would y contribute to those changes? Turn to	you like to see in the world and page 93
Self-discove how can you	ery Journey: What changes would y contribute to those changes? Turn to	You like to see in the world and page 93

Writing a New Chapter Journey: You can have no success without failure. It's better to have a life full of small failures that you learned from, rather than a lifetime filled with the regrets of never trying. What would you regret never trying? Turn to page 94
Mending Fences Journey: How hard is it for you to applicate popular as
Mending Fences Journey: How hard is it for you to apologize to people? Turn to page 94
Mending Fences Journey: How hard is it for you to apologize to people? Turn to page 94
Mending Fences Journey: How hard is it for you to apologize to people? Turn to page 94
Mending Fences Journey: How hard is it for you to apologize to people? Turn to page 94
Mending Fences Journey: How hard is it for you to apologize to people? Turn to page 94
Mending Fences Journey: How hard is it for you to apologize to people? Turn to page 94
Mending Fences Journey: How hard is it for you to apologize to people? Turn to page 94
Mending Fences Journey: How hard is it for you to apologize to people? Turn to page 94

into your life. Wh					
	<i>y</i>				
					100
Spiritual Journ	ey: Do you belie	eve in soulmates? [not? <i>Turn to page 95</i>	Do you think	soulmates hav	е
Spiritual Journ spiritual connect	ey: Do you belie	eve in soulmates? E not? <i>Turn to page 95</i>	Do you think :	soulmates hav	е
Spiritual Journ spiritual connect	ey: Do you belie	eve in soulmates? E not? <i>Turn to page 95</i>	Do you think	soulmates hav	e a
Spiritual Journ spiritual connect	ey: Do you belie ion, why or why	eve in soulmates? [not? <i>Turn to page 95</i>	Do you think :	soulmates hav	е
Spiritual Journ spiritual connect	ey: Do you belie	eve in soulmates? [not? <i>Turn to page 95</i>	Do you think :	soulmates hav	е
Spiritual Journ spiritual connect	ey: Do you belie ion, why or why	eve in soulmates? E not? <i>Turn to page 95</i>	Do you think :	soulmates hav	re a
Spiritual Journ spiritual connect	.ey: Do you belie ion, why or why	eve in soulmates? E not? <i>Turn to page 95</i>	Do you think :	soulmates hav	е
Spiritual Journ spiritual connect	ey: Do you belie ion, why or why	eve in soulmates? E not? <i>Turn to page 95</i>	Do you think :	soulmates hav	e
Spiritual Journ spiritual connect	e y: Do you belie ion, why or why	eve in soulmates? E not? <i>Turn to page 95</i>	Do you think :	soulmates hav	е
Spiritual Journ spiritual connect	ey: Do you belie ion, why or why	eve in soulmates? E not? <i>Turn to page 95</i>	Do you think :	soulmates hav	e e
Spiritual Journ spiritual connect	ey: Do you belie	eve in soulmates? E not? <i>Turn to page 95</i>	Do you think :	soulmates hav	e a
Spiritual Journ spiritual connect	ey: Do you belie	eve in soulmates? [not? <i>Turn to page 95</i>	Do you think	soulmates hav	е
Spiritual Journ spiritual connect	ey: Do you belie	eve in soulmates? E not? Turn to page 95	Do you think	soulmates hav	e d
Spiritual Journ spiritual connect	ey: Do you belie	eve in soulmates? E not? <i>Turn to page 95</i>	Do you think :	soulmates hav	e
Spiritual Journ spiritual connect	ey: Do you belie	eve in soulmates? Enot? Turn to page 95	Do you think :	soulmates hav	re a
Spiritual Journ spiritual connect	ey: Do you belie	eve in soulmates? Enot? Turn to page 95	Do you think :	soulmates hav	e e
Spiritual Journ spiritual connect	ey: Do you belie	eve in soulmates? Enot? Turn to page 95	Do you think :	soulmates hav	е
Spiritual Journ spiritual connect	ey: Do you belie	eve in soulmates? Enot? Turn to page 95	Do you think :	soulmates hav	е

iumanitarian Journey: What kind of neighbor are you? Write about ways you in be more neighborly and what thoughtful things you can do to help out a eighbor in need. Turn to page 96		n Journey: Write about what your greatest strengths, attributes and . Turn to page 96
ın be more neighborly and what thoughtful things you can do to help out a		
ın be more neighborly and what thoughtful things you can do to help out a		
In be more neighborly and what thoughtful things you can do to help out a		
In be more neighborly and what thoughtful things you can do to help out a		
In be more neighborly and what thoughtful things you can do to help out a		
In be more neighborly and what thoughtful things you can do to help out a		
In be more neighborly and what thoughtful things you can do to help out a		
In be more neighborly and what thoughtful things you can do to help out a		
In be more neighborly and what thoughtful things you can do to help out a		
In be more neighborly and what thoughtful things you can do to help out a		
In be more neighborly and what thoughtful things you can do to help out a		
	lumanıtarı	120 Introev. What kind of neighbor are you? Write about ways you
	an be more	neighborly and what thoughtful things you can do to help out a
	an be more	neighborly and what thoughtful things you can do to help out a
	an be more	neighborly and what thoughtful things you can do to help out a
	an be more	neighborly and what thoughtful things you can do to help out a
	an be more	neighborly and what thoughtful things you can do to help out a
	an be more	neighborly and what thoughtful things you can do to help out a
	an be more	neighborly and what thoughtful things you can do to help out a
	an be more	neighborly and what thoughtful things you can do to help out a
	an be more	neighborly and what thoughtful things you can do to help out a

				a .	
					,
Chaotic l	Resolve Jour	ney: Lighten	up. Do you ta	ke things too	seriously or take
yourself to	Resolve Jour oo seriously? (rite about wa	Create a plan	below that w	ill help you lea	seriously or take arn to be more
yourself to	oo seriously? (Create a plan	below that w	ill help you lea	seriously or take arn to be more
yourself to	oo seriously? (Create a plan	below that w	ill help you lea	seriously or take arn to be more
yourself to	oo seriously? (Create a plan	below that w	ill help you lea	seriously or take arn to be more
yourself to	oo seriously? (Create a plan	below that w	ill help you lea	seriously or take arn to be more
yourself to	oo seriously? (Create a plan	below that w	ill help you lea	seriously or take arn to be more
yourself to	oo seriously? (Create a plan	below that w	ill help you lea	seriously or take arn to be more
yourself to	oo seriously? (Create a plan	below that w	ill help you lea	seriously or take arn to be more
yourself to	oo seriously? (Create a plan	below that w	ill help you lea	seriously or take
yourself to	oo seriously? (Create a plan	below that w	ill help you lea	seriously or take
yourself to	oo seriously? (Create a plan	below that w	ill help you lea	seriously or take
yourself to	oo seriously? (Create a plan	below that w	ill help you lea	seriously or take
yourself to	oo seriously? (Create a plan	below that w	ill help you lea	seriously or take
yourself to	oo seriously? (Create a plan	below that w	ill help you lea	seriously or take
yourself to	oo seriously? (Create a plan	below that w	ill help you lea	seriously or take

Achievement Journey: How much do you want it? When you're creating goals and dreams for your life you need to ask yourself some questions. The biggest one is: Do you want it enough to work hard enough to get it? How much do you really want what you're striving for? <i>Turn to page 98</i>	
Self-discovery Journey: How do you feel about writing? What kind of writer do you think you are? <i>Turn to page 98</i>	

	•
Mandina	Fances Journay: Have you taken compone compathing or a position
for granted	Fences Journey: Have you taken someone, something or a position d? How does the saying, "don't know what you've got until it's gone" ou? <i>Turn to page 99</i>
for granted	d? How does the saying, "don't know what you've got until it's gone"
for granted	d? How does the saying, "don't know what you've got until it's gone"
for granted	d? How does the saying, "don't know what you've got until it's gone"
for granted	d? How does the saying, "don't know what you've got until it's gone"
for granted	d? How does the saying, "don't know what you've got until it's gone"
for granted	d? How does the saying, "don't know what you've got until it's gone"
for granted	d? How does the saying, "don't know what you've got until it's gone"
for granted	d? How does the saying, "don't know what you've got until it's gone"
for granted	d? How does the saying, "don't know what you've got until it's gone"
for granted	d? How does the saying, "don't know what you've got until it's gone"
for granted	d? How does the saying, "don't know what you've got until it's gone"
for granted	d? How does the saying, "don't know what you've got until it's gone"
for granted	d? How does the saying, "don't know what you've got until it's gone"
for granted	d? How does the saying, "don't know what you've got until it's gone"
for granted	d? How does the saying, "don't know what you've got until it's gone"
for granted	d? How does the saying, "don't know what you've got until it's gone"
for granted	d? How does the saying, "don't know what you've got until it's gone"

) -	ers. In what wa ears? <i>Turn to pag</i>	100		
					,
piritual Jou elief system?	rney: How do s	science and r	nan-made th	eories line up	o with your
piritual Jou elief system?	rney: How do s	science and r	nan-made th	eories line up	o with your
piritual Jou elief system?	rney: How do s	science and r	nan-made th	eories line uț	o with your
piritual Jou elief system?	rney: How do s	science and r	nan-made the	eories line up	o with your
piritual Jou elief system?	rney: How do s	science and r	nan-made th	eories line up	o with your
piritual Jou elief system?	rney: How do s	science and r	nan-made th	eories line up	o with your
piritual Jou elief system?	rney: How do:	science and r	nan-made th	eories line up	o with your
piritual Jou elief system?	rney: How do:	science and r	nan-made th	eories line up	o with your
piritual Jou elief system?	rney: How do:	science and r	nan-made th	eories line up	o with your
piritual Jou elief system?	rney: How do:	science and r	nan-made th	eories line up	o with your
piritual Jou elief system?	rney: How do:	science and r	nan-made th	eories line up	o with your

orofits to compa what wh					
orofits to compa what wh					
orofits to compa what wh					
orofits to compa what wh					
orofits to compa what wh					
orofits to compa what wh					
orofits to compa what wh					
orofits to compa what wh					
orofits to compa what wh					
orofits to compa what wh					
orofits to compa what wh					
orofits to compa what wh					
orofits to compa what wh					
orofits to compa what wh					
orofits to compa what wh					
orofits to compa what wh	:				
orofits to compa what wh	:				
	nitarian Journey: Find to charity like Grace & I any that you like and t any you like and suppor Furn to page 101	Lace, Pura V hat supports	ida or H&M. s something	You can se	arch online for e in. Write about

Overcomer's Write about it.	S Journey: Is your fear standing in the way of your goals or dreams? . Turn to page 102
emotional trig keep your em	olve Journey: Keep your emotions in check. Figure out what your gers are and how they are impacting your life negatively. Don't otions bottled up, find healthy outlets for your emotions. Write utlets. <i>Turn to page 102</i>

help? Turn to p	8		
Self-discove	ery Journey: If yo	ou were to write your first b	book, what would it be
Self-discove	ery Journey: If yo	ou were to write your first b	book, what would it be
Self-discove about? Turn to	ery Journey: If yo	ou were to write your first b	pook, what would it be
Self-discove about? <i>Turn to</i>	ery Journey: If yo	ou were to write your first b	book, what would it be
Self-discove about? <i>Turn to</i>	ery Journey: If yo	ou were to write your first b	book, what would it be
Self-discove about? <i>Turn te</i>	ery Journey: If yo	ou were to write your first b	book, what would it be
Self-discov about? <i>Turn to</i>	ery Journey: If yo	ou were to write your first b	book, what would it be
Self-discove about? Turn to	ery Journey: If yo	ou were to write your first b	book, what would it be
Self-discove about? Turn to	ery Journey: If yo	ou were to write your first b	book, what would it be
Self-discove about? Turn to	ery Journey: If yo	ou were to write your first b	book, what would it be
Self-discove about? Turn to	ery Journey: If yo	ou were to write your first b	book, what would it be
Self-discove about? Turn to	ery Journey: If yo	ou were to write your first b	book, what would it be
Self-discove about? Turn to	ery Journey: If yo	ou were to write your first b	book, what would it be
Self-discove about? Turn to	ery Journey: If yo	ou were to write your first b	book, what would it be
Self-discove	ery Journey: If yo	ou were to write your first b	book, what would it be
Self-discove	ery Journey: If yo	ou were to write your first b	book, what would it be
Self-discove about? Turn to	ery Journey: If yo	ou were to write your first b	book, what would it be
Self-discove about? Turn to	ery Journey: If yo	ou were to write your first b	book, what would it be
Self-discove about? Turn to	ery Journey: If yo	ou were to write your first b	book, what would it be

Writing a New Chapter Journey: Nothing is as bad as it seems. Don't magnify your mistakes, rather shift your focus to the solution or lesson. Do you blow mistakes out of proportion? Write about a time you did this. Turn to page 104
Mending Fences Journey: Write a few original song lyrics to your last bad breakup and give the song a title. Did writing help you sort through the pain? <i>Turn to page 104</i>

	to page 105				
Spiritua	1 Journey: Think	k about all the	e religions in th	ne world. Pick a	a religion
different	1 Journey: Think than your own a belief system?	and read a few	e religions in the	ne world. Pick a	a religion they compare
different	than your own a	and read a few	e religions in th	ne world. Pick a ples. How do t	a religion they compare
different	than your own a	and read a few	e religions in th	ne world. Pick a iples. How do t	a religion they compare
different	than your own a	and read a few	e religions in th	ne world. Pick a iples. How do t	a religion they compare
different	than your own a	and read a few	e religions in th	ne world. Pick a iples. How do t	a religion they compare
different	than your own a	and read a few	e religions in th	ne world. Pick a ples. How do t	a religion they compare
different	than your own a	and read a few	e religions in th	ne world. Pick a ples. How do f	a religion they compare
different	than your own a	and read a few	e religions in th	ne world. Pick a iples. How do t	a religion they compare
different	than your own a	and read a few	e religions in th	ne world. Pick a iples. How do t	a religion they compare
different	than your own a	and read a few	e religions in th	ne world. Pick a	a religion they compare
different	than your own a	and read a few	e religions in th	ne world. Pick a	a religion they compare
different	than your own a	and read a few	e religions in th	ne world. Pick a	a religion they compare
different	than your own a	and read a few	e religions in th	ne world. Pick a	a religion they compare
different	than your own a	and read a few	e religions in th	ne world. Pick a	a religion they compare
different	than your own a	and read a few	e religions in the	ne world. Pick a	a religion they compare

Destination Journey: What is your definition of success? Write it in your own words. Then find one photo (from a magazine, online, etc.) that perfectly sums up your true idea of success and paste it below your definition below. <i>Turn to page 106</i>	
Humanitarian Journey: Volunteer at an animal shelter for a day or more. Write about the experience and how you felt. If you can't volunteer, write about how you feel about animal shelters and how they can get better. <i>Turn to page 106</i>	
	8 8

fear. S	your fear doesn't have substance, then it is probably just worry disguised eparate your worry from real fear. <i>Turn to page 107</i>
Chac	tic Resolve Journey: Stop comparing your life to another person's life
Chao Creat	tic Resolve Journey: Stop comparing your life to another person's life. e a list of all the things you love and are thankful for in your life. Turn to page
Chac Creat	tic Resolve Journey: Stop comparing your life to another person's life. e a list of all the things you love and are thankful for in your life. <i>Turn to page</i>
Chac Creat	tic Resolve Journey: Stop comparing your life to another person's life. e a list of all the things you love and are thankful for in your life. Turn to page
Chao Creat	tic Resolve Journey: Stop comparing your life to another person's life. e a list of all the things you love and are thankful for in your life. <i>Turn to page</i>
Chao Creat	tic Resolve Journey: Stop comparing your life to another person's life. e a list of all the things you love and are thankful for in your life. Turn to page
Chao Creat	tic Resolve Journey: Stop comparing your life to another person's life. e a list of all the things you love and are thankful for in your life. Turn to page
Chao Creat	tic Resolve Journey: Stop comparing your life to another person's life. e a list of all the things you love and are thankful for in your life. Turn to page
Chao Creat	tic Resolve Journey: Stop comparing your life to another person's life. e a list of all the things you love and are thankful for in your life. Turn to page
Chac	tic Resolve Journey: Stop comparing your life to another person's life. e a list of all the things you love and are thankful for in your life. Turn to page
Chac	tic Resolve Journey: Stop comparing your life to another person's life. e a list of all the things you love and are thankful for in your life. Turn to page
Chac	tic Resolve Journey: Stop comparing your life to another person's life. e a list of all the things you love and are thankful for in your life. Turn to page
Chac	tic Resolve Journey: Stop comparing your life to another person's life. e a list of all the things you love and are thankful for in your life. Turn to page
Chac	tic Resolve Journey: Stop comparing your life to another person's life. e a list of all the things you love and are thankful for in your life. Turn to page
Chac	tic Resolve Journey: Stop comparing your life to another person's life. e a list of all the things you love and are thankful for in your life. Turn to page
Chac	tic Resolve Journey: Stop comparing your life to another person's life. e a list of all the things you love and are thankful for in your life. Turn to page
Chac	tic Resolve Journey: Stop comparing your life to another person's life. e a list of all the things you love and are thankful for in your life. Turn to page
Chac	tic Resolve Journey: Stop comparing your life to another person's life. e a list of all the things you love and are thankful for in your life. Turn to page
Chac	tic Resolve Journey: Stop comparing your life to another person's life. e a list of all the things you love and are thankful for in your life. Turn to page

Achieve question	ement Journey: If you could ask any successful person in the world one n, who would it be and what would you ask? Turn to page 108
	· · · · · · · · · · · · · · · · · · ·
Self-dis	scovery Journey: How do you feel about poems? Write a short poem our life right now. <i>Turn to page 108</i>

	talk to them, seek advice and receive comfort when you need a boost. Whould be in your support network and why? <i>Turn to page 109</i>
	, , , , ,
	,
Me	nding Fences Journey: Do you listen to others and value people's opinions
othe	nding Fences Journey: Do you listen to others and value people's opinions or than your own? How can you improve your listening skills and value other as more? Turn to page 109
othe	er than your own? How can you improve your listening skills and value other
othe	er than your own? How can you improve your listening skills and value other
othe	er than your own? How can you improve your listening skills and value other
othe	er than your own? How can you improve your listening skills and value other
othe	er than your own? How can you improve your listening skills and value other
othe	er than your own? How can you improve your listening skills and value other
othe	er than your own? How can you improve your listening skills and value other
othe	er than your own? How can you improve your listening skills and value other
othe	er than your own? How can you improve your listening skills and value other
othe	er than your own? How can you improve your listening skills and value other
othe	er than your own? How can you improve your listening skills and value other

orld? Turn to pag					
					X
piritual Journ ou feel about th	ey: Have you r ne Bible and do	read the Bible o you have a f	or any parts of avorite scriptur	f the Bible? How e? Turn to page 11	/ do
piritual Journ ou feel about th	ey: Have you r ne Bible and do	read the Bible o you have a f	or any parts of avorite scriptur	the Bible? How e? Turn to page 11	/ do 0
piritual Journ ou feel about th	ey: Have you r ne Bible and do	read the Bible o you have a f	or any parts of avorite scriptur	the Bible? How e? Turn to page 11	/ do 0
piritual Journ ou feel about th	ey: Have you r ne Bible and do	read the Bible o you have a f	or any parts of avorite scriptur	f the Bible? How e? Turn to page 11	v do 0
piritual Journ ou feel about th	ey: Have you r ne Bible and do	read the Bible o you have a f	or any parts of avorite scriptur	f the Bible? How e? <i>Turn to page 11</i>	v do 0
piritual Journ ou feel about th	ey: Have you r ne Bible and do	read the Bible to you have a f	or any parts of avorite scriptur	f the Bible? How e? Turn to page 11	/ do 0
piritual Journ ou feel about th	ey: Have you r ne Bible and do	read the Bible by you have a f	or any parts of avorite scriptur	the Bible? How e? Turn to page 11	v do 0
piritual Journ ou feel about th	ey: Have you r ne Bible and do	read the Bible by you have a f	or any parts of avorite scriptur	the Bible? How	v do 0
piritual Journ ou feel about th	ey: Have you r ne Bible and do	read the Bible by you have a f	or any parts of avorite scriptur	the Bible? How	v do 0
piritual Journ ou feel about th	ey: Have you r ne Bible and do	read the Bible by you have a f	or any parts of avorite scriptur	f the Bible? How e? Turn to page 11	v do 0
piritual Journ ou feel about th	ey: Have you r ne Bible and do	read the Bible o you have a f	or any parts of avorite scriptur	f the Bible? How e? Turn to page 11	v do
piritual Journ ou feel about th	ey: Have you r ne Bible and do	read the Bible by you have a f	or any parts of avorite scriptur	the Bible? How	v do o
piritual Journ bu feel about th	ey: Have you r ne Bible and do	read the Bible by you have a f	or any parts of avorite scriptur	the Bible? How	v do 0
piritual Journ Du feel about th	ey: Have you r ne Bible and do	read the Bible by you have a f	or any parts of avorite scriptur	the Bible? How	y do
piritual Journ bu feel about th	ey: Have you r	read the Bible by you have a f	or any parts of avorite scriptur	f the Bible? How	/ do 0

you back? Wha				
Humanitariar	a Journey: Start a	recycling progran	n in your own house. If	you
already recycle	a Journey: Start a t, then try and get portant. <i>Turn to page</i>	others involved. W	n in your own house. If /rite about why you thi	you nk
already recycle	, then try and get	others involved. W	n in your own house. If /rite about why you thi	you nk
already recycle	, then try and get	others involved. W	n in your own house. If /rite about why you thi	you nk
already recycle	, then try and get	others involved. W	n in your own house. If /rite about why you thi	you nk
already recycle	, then try and get	others involved. W	n in your own house. If /rite about why you thi	you nk
already recycle	, then try and get	others involved. W	n in your own house. If /rite about why you thi	you nk
already recycle	, then try and get	others involved. W	n in your own house. If /rite about why you thi	you nk
already recycle	, then try and get	others involved. W	n in your own house. If /rite about why you thi	you nk
already recycle	, then try and get	others involved. W	n in your own house. If /rite about why you thi	you nk
already recycle	, then try and get	others involved. W	n in your own house. If /rite about why you thi	you nk
already recycle	, then try and get	others involved. W	n in your own house. If /rite about why you thi	you nk
already recycle	, then try and get	others involved. W	n in your own house. If /rite about why you thi	you nk
already recycle	, then try and get	others involved. W	n in your own house. If /rite about why you thi	you nk
already recycle	, then try and get	others involved. W	n in your own house. If /rite about why you thi	you nk
already recycle	, then try and get	others involved. W	n in your own house. If /rite about why you thi	you nk
already recycle	, then try and get	others involved. W	n in your own house. If /rite about why you thi	you nk

	egative things can manifest fear. Write about how these toxic things could be entributing to your fear and how you can address this. <i>Turn to page 112</i>
CI on	haotic Resolve Journey: Write about how you can be nicer to more people a daily basis. <i>Turn to page 112</i>

Self-discov	very Journey: Go	back and read th	e poem you just w	rote, what is
Self-discov missing fron	very Journey: Go n your life that you	back and read the want reflected ir	e poem you just wi in that poem? <i>Turn to</i>	rote, what is a page 113
Self-discov missing fron	very Journey: Go n your life that you	back and read the want reflected ir	e poem you just wi In that poem? <i>Turn to</i>	rote, what is page 113
Self-discov missing fron	very Journey: Go n your life that you	back and read the	e poem you just wi I that poem? <i>Turn t</i> e	rote, what is o page 113
Self-discov missing fron	very Journey: Go m your life that you	back and read the	e poem you just wi In that poem? <i>Turn to</i>	rote, what is o page 113
Self-discov missing fron	very Journey: Go n your life that you	back and read the	e poem you just wi In that poem? <i>Turn to</i>	rote, what is o page 113
Self-discov missing fron	very Journey: Go n your life that you	back and read the	e poem you just wi I that poem? <i>Turn to</i>	rote, what is a page 113
Self-discov missing fron	very Journey: Go m your life that you	back and read the	e poem you just wi that poem? <i>Turn t</i> e	rote, what is o page 113
Self-discov missing fron	very Journey: Go n your life that you	back and read the	e poem you just wi in that poem? <i>Turn to</i>	rote, what is a page 113
Self-discov missing fron	very Journey: Go n your life that you	back and read the	e poem you just wi i that poem? <i>Turn to</i>	rote, what is a page 113
Self-discov missing fron	very Journey: Go n your life that you	back and read the	e poem you just wi that poem? <i>Turn to</i>	rote, what is a page 113
Self-discov missing fron	very Journey: Go n your life that you	back and read the	e poem you just wi that poem? <i>Turn to</i>	rote, what is o page 113
Self-discov missing fron	very Journey: Go n your life that you	back and read the	e poem you just wi in that poem? <i>Turn to</i>	rote, what is a page 113
Self-discov missing fron	very Journey: Go n your life that you	back and read the	e poem you just wi i that poem? <i>Turn to</i>	rote, what is a page 113
Self-discov missing fron	very Journey: Go n your life that you	back and read the	e poem you just wi that poem? <i>Turn to</i>	rote, what is o page 113

Writing a New Chapter Journey: Dust yourself off and get back out there. Life will knock you down and often times it's in the form of a mistake or setback. Mistakes are proof of your progress, it's practice in motion and evidence you're trying. Write about something you did over and over again until you got it right. Turn to page 114	
M I: D I	
Mending Fences Journey: How easy are you to get along with? What are some things you need to do to improve your relationships with others? <i>Turn to page 114</i>	
Mending Fences Journey: How easy are you to get along with? What are some things you need to do to improve your relationships with others? Turn to page 114	
Mending Fences Journey: How easy are you to get along with? What are some things you need to do to improve your relationships with others? Turn to page 114	
Mending Fences Journey: How easy are you to get along with? What are some things you need to do to improve your relationships with others? Turn to page 114	
Mending Fences Journey: How easy are you to get along with? What are some things you need to do to improve your relationships with others? Turn to page 114	
Mending Fences Journey: How easy are you to get along with? What are some things you need to do to improve your relationships with others? Turn to page 114	
Mending Fences Journey: How easy are you to get along with? What are some things you need to do to improve your relationships with others? Turn to page 114	
Mending Fences Journey: How easy are you to get along with? What are some things you need to do to improve your relationships with others? Turn to page 114	

yourself today. Imm to	all and treat yourself kind. What nice thing will you do for page 115
Spiritual Journey: ⊢	low do you apply your spiritual beliefs and principles to you
Spiritual Journey: Hife? Turn to page 115	low do you apply your spiritual beliefs and principles to you
Spiritual Journey: Hife? Turn to page 115	low do you apply your spiritual beliefs and principles to you
Spiritual Journey: Hife? Turn to page 115	low do you apply your spiritual beliefs and principles to you
Spiritual Journey: Hife? Turn to page 115	low do you apply your spiritual beliefs and principles to you
Spiritual Journey: Hife? Turn to page 115	low do you apply your spiritual beliefs and principles to you
Spiritual Journey: Hife? Turn to page 115	low do you apply your spiritual beliefs and principles to you
Spiritual Journey: Hife? Turn to page 115	low do you apply your spiritual beliefs and principles to you
Spiritual Journey: Hife? Turn to page 115	low do you apply your spiritual beliefs and principles to you
Spiritual Journey: Hife? Turn to page 115	low do you apply your spiritual beliefs and principles to you
Spiritual Journey: Hife? Turn to page 115	low do you apply your spiritual beliefs and principles to you
Spiritual Journey: Hife? Turn to page 115	low do you apply your spiritual beliefs and principles to you
Spiritual Journey: Hife? Turn to page 115	low do you apply your spiritual beliefs and principles to you
Spiritual Journey: Hife? Turn to page 115	low do you apply your spiritual beliefs and principles to you
Spiritual Journey: Hife? Turn to page 115	low do you apply your spiritual beliefs and principles to you
Spiritual Journey: Hife? Turn to page 115	low do you apply your spiritual beliefs and principles to you
Spiritual Journey: Hife? Turn to page 115	low do you apply your spiritual beliefs and principles to you
Spiritual Journey: Hife? Turn to page 115	low do you apply your spiritual beliefs and principles to you
Spiritual Journey: Hife? Turn to page 115	low do you apply your spiritual beliefs and principles to you
Spiritual Journey: Hife? Turn to page 115	low do you apply your spiritual beliefs and principles to you
Spiritual Journey: Hife? Turn to page 115	low do you apply your spiritual beliefs and principles to you

)	Destination Journey: Describe the biggest leap of faith you've taken thus far in your life. Write about 2 or 3 new leaps of faith you may have to take to find your burpose? Turn to page 116
0	Humanitarian Journey: How do you feel about small businesses and local armers? Try and research local farmers in your area and write about what you earned. <i>Turn to page 116</i>

can y	ou do to otar e		,	1.0	. 7		
Chao	tic Resolve	Journey: P	Practice rela	axation tech	niques and	implement th	hen
into y	otic Resolve our life. Yoga ique you plai	, meditation	, breathing	or any tech	nique. Write	about what	hen
into y	our life. Yoga	, meditation	, breathing	or any tech	nique. Write	about what	hen
into y	our life. Yoga	, meditation	, breathing	or any tech	nique. Write	about what	hen
into y	our life. Yoga	, meditation	, breathing	or any tech	nique. Write	about what	hen
into y	our life. Yoga	, meditation	, breathing	or any tech	nique. Write	about what	nem
into y	our life. Yoga	, meditation	, breathing	or any tech	nique. Write	about what	nem
into y	our life. Yoga	, meditation	, breathing	or any tech	nique. Write	about what	hem
into y	our life. Yoga	, meditation	, breathing	or any tech	nique. Write	about what	hen
into y	our life. Yoga	, meditation	, breathing	or any tech	nique. Write	about what	nem
into y	our life. Yoga	, meditation	, breathing	or any tech	nique. Write	about what	hen
into y	our life. Yoga	, meditation	, breathing	or any tech	nique. Write	about what	hen
into y	our life. Yoga	, meditation	, breathing	or any tech	nique. Write	about what	nem
into y	our life. Yoga	, meditation	, breathing	or any tech	nique. Write	about what	nem
into y	our life. Yoga	, meditation	, breathing	or any tech	nique. Write	about what	hen
into y	our life. Yoga	, meditation	, breathing	or any tech	nique. Write	about what	hen

Achievement Journey: Don't accept "good enough" If you are going through the motions of life but you don't feel like you're living, then you need to evaluate your life. Don't settle for a life you don't want; rather work for a life you'll love. Where do you think you've settled for less than you wanted? Turn to page 118	
	4
Self-discovery Journey: What was the craziest idea for your life you had as a child? Does it still seem crazy and if so why? <i>Turn to page 118</i>	
Self-discovery Journey: What was the craziest idea for your life you had as a child? Does it still seem crazy and if so why? <i>Turn to page 118</i>	
Self-discovery Journey: What was the craziest idea for your life you had as a child? Does it still seem crazy and if so why? <i>Turn to page 118</i>	
Self-discovery Journey: What was the craziest idea for your life you had as a child? Does it still seem crazy and if so why? Turn to page 118	
Self-discovery Journey: What was the craziest idea for your life you had as a child? Does it still seem crazy and if so why? Turn to page 118	
Self-discovery Journey: What was the craziest idea for your life you had as a child? Does it still seem crazy and if so why? Turn to page 118	
Self-discovery Journey: What was the craziest idea for your life you had as a child? Does it still seem crazy and if so why? Turn to page 118	
Self-discovery Journey: What was the craziest idea for your life you had as a child? Does it still seem crazy and if so why? Turn to page 118	
Self-discovery Journey: What was the craziest idea for your life you had as a child? Does it still seem crazy and if so why? Turn to page 118	
Self-discovery Journey: What was the craziest idea for your life you had as a child? Does it still seem crazy and if so why? Turn to page 118	

	Writing a New Chapter Journey: Not all mistakes involve work, some are relationships. Have you ever made a mistake in a relationship? What did you do? <i>Turn to page 119</i>
_	
_	
	Mending Fences Journey: Do you have any prejudices that make you alienate specific people for one thing or another? Practice acceptance. In life, we have to learn to agree to disagree. Look at yourself in the mirror, now write about what you see. <i>Turn to page 119</i>
	specific people for one thing or another? Practice acceptance. In life, we have to learn to agree to disagree. Look at yourself in the mirror, now write about what
	specific people for one thing or another? Practice acceptance. In life, we have to learn to agree to disagree. Look at yourself in the mirror, now write about what
	specific people for one thing or another? Practice acceptance. In life, we have to learn to agree to disagree. Look at yourself in the mirror, now write about what
	specific people for one thing or another? Practice acceptance. In life, we have to learn to agree to disagree. Look at yourself in the mirror, now write about what
	specific people for one thing or another? Practice acceptance. In life, we have to learn to agree to disagree. Look at yourself in the mirror, now write about what
	specific people for one thing or another? Practice acceptance. In life, we have to learn to agree to disagree. Look at yourself in the mirror, now write about what
	specific people for one thing or another? Practice acceptance. In life, we have to learn to agree to disagree. Look at yourself in the mirror, now write about what
	specific people for one thing or another? Practice acceptance. In life, we have to learn to agree to disagree. Look at yourself in the mirror, now write about what
	specific people for one thing or another? Practice acceptance. In life, we have to learn to agree to disagree. Look at yourself in the mirror, now write about what
	specific people for one thing or another? Practice acceptance. In life, we have to learn to agree to disagree. Look at yourself in the mirror, now write about what
	specific people for one thing or another? Practice acceptance. In life, we have to learn to agree to disagree. Look at yourself in the mirror, now write about what
	specific people for one thing or another? Practice acceptance. In life, we have to learn to agree to disagree. Look at yourself in the mirror, now write about what

Self-improvement Journey: Create a cheerful environment. Whatever make you smile, put that into your special place. Fresh flowers, candles, extra pillows anything goes! How will you create a cheerful environment? <i>Turn to page 120</i>	5
	7.4
Spiritual Journey: Do you believe in Heaven and Hell? Why or why not? <i>Turn to page 120</i>	0
page 120	

findings bel	OW. Turn to page 121
Humanita	rian Journey: Have you ever volunteered at a shelter? What do you shelters and do you have any plans to volunteer in the future? Turn
know about	rian Journey: Have you ever volunteered at a shelter? What do you shelters and do you have any plans to volunteer in the future? <i>Turn</i>
know about	rian Journey: Have you ever volunteered at a shelter? What do you shelters and do you have any plans to volunteer in the future? <i>Turn</i>
know about	rian Journey: Have you ever volunteered at a shelter? What do you shelters and do you have any plans to volunteer in the future? <i>Turn</i>
know about	rian Journey: Have you ever volunteered at a shelter? What do you shelters and do you have any plans to volunteer in the future? <i>Turn</i>
know about	rian Journey: Have you ever volunteered at a shelter? What do you shelters and do you have any plans to volunteer in the future? <i>Turn</i>
know about	rian Journey: Have you ever volunteered at a shelter? What do you shelters and do you have any plans to volunteer in the future? <i>Turn</i>
know about	rian Journey: Have you ever volunteered at a shelter? What do you shelters and do you have any plans to volunteer in the future? Turn
know about	rian Journey: Have you ever volunteered at a shelter? What do you shelters and do you have any plans to volunteer in the future? Turn
know about	rian Journey: Have you ever volunteered at a shelter? What do you shelters and do you have any plans to volunteer in the future? Turn
know about	rian Journey: Have you ever volunteered at a shelter? What do you shelters and do you have any plans to volunteer in the future? Turn
Humanita know about page 121	rian Journey: Have you ever volunteered at a shelter? What do you shelters and do you have any plans to volunteer in the future? Turn
know about	rian Journey: Have you ever volunteered at a shelter? What do you shelters and do you have any plans to volunteer in the future? Turn
know about	rian Journey: Have you ever volunteered at a shelter? What do you shelters and do you have any plans to volunteer in the future? Turn
know about	rian Journey: Have you ever volunteered at a shelter? What do you shelters and do you have any plans to volunteer in the future? Turn
know about	rian Journey: Have you ever volunteered at a shelter? What do you shelters and do you have any plans to volunteer in the future? Turn
know about	rian Journey: Have you ever volunteered at a shelter? What do you shelters and do you have any plans to volunteer in the future? Turn
know about	rian Journey: Have you ever volunteered at a shelter? What do you shelters and do you have any plans to volunteer in the future? Turn
know about	rian Journey: Have you ever volunteered at a shelter? What do you shelters and do you have any plans to volunteer in the future? Turn
know about	rian Journey: Have you ever volunteered at a shelter? What do you shelters and do you have any plans to volunteer in the future? Turn
know about	rian Journey: Have you ever volunteered at a shelter? What do you shelters and do you have any plans to volunteer in the future? Turn

did you le	ner's Journey: Educate yourself about a specific fear you have earn? <i>Turn to page 122</i>	ave. What
Chaotic Pou're goi	Resolve Journey: Become more enlightened. Write about ing to try on your journey of enlightenment. <i>Turn to page 122</i>	things
Chaotic I ou're goi	Resolve Journey: Become more enlightened. Write about ing to try on your journey of enlightenment. <i>Turn to page 122</i>	things
Chaotic I	Resolve Journey: Become more enlightened. Write about ing to try on your journey of enlightenment. <i>Turn to page 122</i>	things
Chaotic I	Resolve Journey: Become more enlightened. Write about ing to try on your journey of enlightenment. <i>Turn to page 122</i>	things
Chaotic I	Resolve Journey: Become more enlightened. Write about ing to try on your journey of enlightenment. <i>Turn to page 122</i>	things
Chaotic I	Resolve Journey: Become more enlightened. Write about ing to try on your journey of enlightenment. Turn to page 122	things
Chaotic I	Resolve Journey: Become more enlightened. Write about ing to try on your journey of enlightenment. Turn to page 122	things
Chaotic I	Resolve Journey: Become more enlightened. Write about ing to try on your journey of enlightenment. Turn to page 122	things
Chaotic l	Resolve Journey: Become more enlightened. Write about ing to try on your journey of enlightenment. Turn to page 122	things
Chaotic I	Resolve Journey: Become more enlightened. Write about ing to try on your journey of enlightenment. Turn to page 122	things
Chaotic l	Resolve Journey: Become more enlightened. Write about ing to try on your journey of enlightenment. Turn to page 122	things

Self-discovery	Journey: Take an a	artistic class. It c	an be free or not	but take a
least one class in	Journey: Take an a n or around your co a about your experie	mmunity that re	equires you to be	but take a artistic in
least one class in	n or around your co	mmunity that re	equires you to be	but take a artistic in
least one class in	n or around your co	mmunity that re	equires you to be	but take a artistic in
least one class in	n or around your co	mmunity that re	equires you to be	but take a artistic in
least one class in	n or around your co	mmunity that re	equires you to be	but take a artistic in
least one class in	n or around your co	mmunity that re	equires you to be	but take a artistic in
least one class in	n or around your co	mmunity that re	equires you to be	but take a artistic in
least one class in	n or around your co	mmunity that re	equires you to be	but take a artistic in
least one class in	n or around your co	mmunity that re	equires you to be	but take a artistic in
least one class in	n or around your co	mmunity that re	equires you to be	but take a artistic in
least one class in	n or around your co	mmunity that re	equires you to be	but take a artistic in
least one class in	n or around your co	mmunity that re	equires you to be	but take a artistic in
least one class in	n or around your co	mmunity that re	equires you to be	but take a artistic in
least one class in	n or around your co	mmunity that re	equires you to be	but take a artistic in
least one class in	n or around your co	mmunity that re	equires you to be	but take a artistic in
least one class in	n or around your co	mmunity that re	equires you to be	but take a artistic in
least one class in	n or around your co	mmunity that re	equires you to be	but take a artistic in
least one class in	n or around your co	mmunity that re	equires you to be	but take a artistic in

		ame others fo			
		2 10			
10					
					-
lending Fend	ces Journey: Ke	eep your ego	in check. Cor	ifidence is he	althy, but
lending Fending Fendentists Cancel ge 124	ces Journey: Ke	eep your ego onceited? Wh	in check. Cor lat makes you	ifidence is he u feel confide	althy, but ent? <i>Turn to</i>
nceit is cance	ces Journey: Ke	eep your ego onceited? Wh	in check. Cor lat makes you	ifidence is he u feel confide	althy, but ent? <i>Turn to</i>
nceit is cance	ces Journey: Ke Prous. Are you co	eep your ego onceited? Wh	in check. Cor lat makes you	ifidence is he u feel confide	althy, but ent? <i>Turn to</i>
nceit is cance	ces Journey: Ke	eep your ego onceited? Wh	in check. Cor nat makes you	ifidence is he u feel confide	althy, but ent? <i>Turn to</i>
nceit is cance	ces Journey: Ke	eep your ego onceited? Wh	in check. Cor lat makes you	ifidence is he u feel confide	althy, but ent? <i>Turn to</i>
nceit is cance	ces Journey: Ke	eep your ego onceited? Wh	in check. Cor nat makes you	ifidence is he u feel confide	althy, but ent? Turn to
nceit is cance	ces Journey: Ke	eep your ego onceited? Wh	in check. Cor lat makes you	ifidence is he u feel confide	althy, but
nceit is cance	ces Journey: Ke	eep your ego onceited? Wh	in check. Cor lat makes you	ifidence is he	althy, but
nceit is cance	ces Journey: Ke	eep your ego onceited? Wh	in check. Cor nat makes you	ifidence is he	althy, but
nceit is cance	ces Journey: Ke	eep your ego onceited? Wh	in check. Cor lat makes you	ifidence is he	althy, but
nceit is cance	ces Journey: Ke	eep your ego onceited? Wh	in check. Cor nat makes you	ifidence is he	althy, but

favorite wav to get s	e to spoil yourself and appreciate yourself more. What spoiled? <i>Turn to page 125</i>	, , , , ,
, , , , , , , , , , , , , , , , , , , ,	1 0	
you practice forgive	: How important is forgiveness in your spiritual journey eness? Do you have someone you need to forgive, or	/? Do does
you practice forgive	: How important is forgiveness in your spiritual journey eness? Do you have someone you need to forgive, or forgive you? <i>Turn to page 125</i>	/? Do does
you practice forgive	eness? Do you have someone you need to forgive, or	/? Do does
you practice forgive	eness? Do you have someone you need to forgive, or	/? Do does
you practice forgive	eness? Do you have someone you need to forgive, or	/? Do does
you practice forgive	eness? Do you have someone you need to forgive, or	/? Do does
you practice forgive	eness? Do you have someone you need to forgive, or	/? Do does
you practice forgive	eness? Do you have someone you need to forgive, or	/? Do does
you practice forgive	eness? Do you have someone you need to forgive, or	/? Do does
you practice forgive	eness? Do you have someone you need to forgive, or	/? Do does
you practice forgive	eness? Do you have someone you need to forgive, or	/? Do does
you practice forgive	eness? Do you have someone you need to forgive, or	/? Do does
you practice forgive	eness? Do you have someone you need to forgive, or	/? Do does
you practice forgive	eness? Do you have someone you need to forgive, or	/? Do does
you practice forgive	eness? Do you have someone you need to forgive, or	/? Do does

	u? Turn to page 126	
.		
Humanit a hat you do	rian Journey: Donate something of your own to charity. Write about onated and where you donated it. <i>Turn to page 126</i>	
Humanita hat you do	rian Journey: Donate something of your own to charity. Write about onated and where you donated it. <i>Turn to page 126</i>	
Humanita hat you do	rian Journey: Donate something of your own to charity. Write about onated and where you donated it. <i>Turn to page 126</i>	
Humanita hat you do	rian Journey: Donate something of your own to charity. Write about onated and where you donated it. <i>Turn to page 126</i>	
Humanita That you do	rian Journey: Donate something of your own to charity. Write about onated and where you donated it. <i>Turn to page 126</i>	
Humanita yhat you do	rian Journey: Donate something of your own to charity. Write about onated and where you donated it. <i>Turn to page 126</i>	
Humanita : what you do	rian Journey: Donate something of your own to charity. Write about onated and where you donated it. <i>Turn to page 126</i>	
Humanita: yhat you do	rian Journey: Donate something of your own to charity. Write about onated and where you donated it. <i>Turn to page 126</i>	
Humanita what you do	rian Journey: Donate something of your own to charity. Write about onated and where you donated it. <i>Turn to page 126</i>	
Humanita: what you do	rian Journey: Donate something of your own to charity. Write about onated and where you donated it. Turn to page 126	
Humanita: what you do	rian Journey: Donate something of your own to charity. Write about onated and where you donated it. Turn to page 126	

	Overcomer's Journey: What happens to you when you feel afraid? What are the symptoms of your fear? <i>Turn to page 127</i>	
_		
_		
	Chaotic Resolve Journey: Are you mad at yourself about something? Write about ways you're too hard on yourself and how you can forgive and ease up your self-expectations. <i>Turn to page 127</i>	
	about ways you're too hard on yourself and how you can forgive and ease up	
	about ways you're too hard on yourself and how you can forgive and ease up	
	about ways you're too hard on yourself and how you can forgive and ease up	
	about ways you're too hard on yourself and how you can forgive and ease up	
	about ways you're too hard on yourself and how you can forgive and ease up	
	about ways you're too hard on yourself and how you can forgive and ease up	
	about ways you're too hard on yourself and how you can forgive and ease up	
	about ways you're too hard on yourself and how you can forgive and ease up	
	about ways you're too hard on yourself and how you can forgive and ease up	
	about ways you're too hard on yourself and how you can forgive and ease up	
	about ways you're too hard on yourself and how you can forgive and ease up	
	about ways you're too hard on yourself and how you can forgive and ease up	
	about ways you're too hard on yourself and how you can forgive and ease up	

Achievement Journey: Write about goals you've recently accomplished. $\textit{Turn page 128}$	n to
	10
Self-discovery Journey: Think about the past few years of your life. Did you make yourself any promises you didn't keep that would have made your life fe more fulfilled? <i>Turn to page 128</i>	el

Mending Fences Journa	ey: Do something nice for someone who cannot pay
Mending Fences Journe you back. Write about you	ey: Do something nice for someone who cannot pay ur experience. <i>Turn to page 129</i>
Mending Fences Journa you back. Write about you	ey: Do something nice for someone who cannot pay ur experience. <i>Turn to page 129</i>
Mending Fences Journa you back. Write about you	ey: Do something nice for someone who cannot pay ur experience. <i>Turn to page 129</i>
Mending Fences Journa you back. Write about you	ey: Do something nice for someone who cannot pay ur experience. <i>Turn to page 129</i>
Mending Fences Journa you back. Write about you	ey: Do something nice for someone who cannot pay ur experience. <i>Turn to page 129</i>
Mending Fences Journa you back. Write about you	ey: Do something nice for someone who cannot pay ur experience. <i>Turn to page 129</i>
Mending Fences Journa you back. Write about you	ey: Do something nice for someone who cannot pay ur experience. <i>Turn to page 129</i>
Mending Fences Journa you back. Write about you	ey: Do something nice for someone who cannot pay ur experience. <i>Turn to page 129</i>
Mending Fences Journa you back. Write about you	ey: Do something nice for someone who cannot pay ur experience. Turn to page 129
Mending Fences Journa you back. Write about you	ey: Do something nice for someone who cannot pay ur experience. Turn to page 129
Mending Fences Journa you back. Write about you	ey: Do something nice for someone who cannot pay ur experience. Turn to page 129
Mending Fences Journa you back. Write about you	ey: Do something nice for someone who cannot pay ur experience. Turn to page 129
Mending Fences Journa you back. Write about you	ey: Do something nice for someone who cannot pay ur experience. Turn to page 129
Mending Fences Journa you back. Write about you	ey: Do something nice for someone who cannot pay ur experience. Turn to page 129
Mending Fences Journe you back. Write about you	ey: Do something nice for someone who cannot pay ur experience. Turn to page 129
Mending Fences Journe you back. Write about you	ey: Do something nice for someone who cannot pay ur experience. Turn to page 129
Mending Fences Journe you back. Write about you	ey: Do something nice for someone who cannot pay ur experience. Turn to page 129
Mending Fences Journe you back. Write about you	ey: Do something nice for someone who cannot pay ur experience. Turn to page 129
Mending Fences Journe you back. Write about you	ey: Do something nice for someone who cannot pay ur experience. Turn to page 129

and make a plan	ent Journey: Get to move in that d	lirection. What	are your firs	t steps? Turn	to page 130
piritual Journ	ey: Make a list of	your values. In	clude what y	ou think is ri	ght and
piritual Journ rrong behavior.	ey: Make a list of Turn to page 130	your values. In	clude what y	you think is ri	ght and
piritual Journ rrong behavior.	ey: Make a list of Turn to page 130	your values. In	clude what y	ou think is ri	ght and
piritual Journ rrong behavior.	ey: Make a list of Turn to page 130	your values. In	clude what y	ou think is ri	ght and
piritual Journ rrong behavior.	ey: Make a list of Turn to page 130	your values. In	clude what y	ou think is ri	ght and
piritual Journ rrong behavior.	ey: Make a list of Turn to page 130	your values. In	clude what y	ou think is rig	ght and
piritual Journ rrong behavior.	ey: Make a list of Turn to page 130	your values. In	clude what y	ou think is ri	ght and
piritual Journ rrong behavior.	ey: Make a list of	your values. In	clude what y	ou think is ri	ght and
piritual Journ rrong behavior.	ey: Make a list of	your values. In	clude what y	ou think is rig	ght and
piritual Journ rrong behavior.	ey: Make a list of Turn to page 130	your values. In	clude what y	ou think is rig	ght and
piritual Journ rrong behavior.	ey: Make a list of Turn to page 130	your values. In	clude what y	ou think is rig	ght and
piritual Journ vrong behavior.	ey: Make a list of	your values. In	clude what y	you think is rig	ght and

	·
tro	amanitarian Journey: Write about what causes going on in the world today uble you. If you had unlimited means how would you contribute to make a serence. Turn to page 134
tro	uble you. If you had unlimited means how would you contribute to make a
tro	uble you. If you had unlimited means how would you contribute to make a
tro	uble you. If you had unlimited means how would you contribute to make a
tro	uble you. If you had unlimited means how would you contribute to make a
tro	uble you. If you had unlimited means how would you contribute to make a
tro	uble you. If you had unlimited means how would you contribute to make a
tro	uble you. If you had unlimited means how would you contribute to make a
tro	uble you. If you had unlimited means how would you contribute to make a
tro	uble you. If you had unlimited means how would you contribute to make a
tro	uble you. If you had unlimited means how would you contribute to make a
tro	uble you. If you had unlimited means how would you contribute to make a
tro	uble you. If you had unlimited means how would you contribute to make a
tro	uble you. If you had unlimited means how would you contribute to make a
tro	uble you. If you had unlimited means how would you contribute to make a

Overcomer's Jou about some positive fear. Turn to page 136	rrney: Write something positive about fear you're facing. Write ve aspects that will come from your fear or addressing your
mpossible in the ti	Journey: Set reasonable goals. If your goals or to-do lists are me frame you've set, then adjust. Don't set yourself up for unreasonable expectations for yourself? <i>Turn to page 138</i>

_	
_	
_	
	Self-discovery Journey: Do you make New Year's resolutions? What resolution keeps coming up year after year that you're not accomplishing? Do any of your resolutions cause you to make drastic changes? <i>Turn to page 142</i>
	keeps coming up year after year that you're not accomplishing? Do any of your
	keeps coming up year after year that you're not accomplishing? Do any of your
	keeps coming up year after year that you're not accomplishing? Do any of your
	keeps coming up year after year that you're not accomplishing? Do any of your
	Self-discovery Journey: Do you make New Year's resolutions? What resolutio keeps coming up year after year that you're not accomplishing? Do any of your resolutions cause you to make drastic changes? <i>Turn to page 142</i>
	keeps coming up year after year that you're not accomplishing? Do any of your
	keeps coming up year after year that you're not accomplishing? Do any of your
	keeps coming up year after year that you're not accomplishing? Do any of your
	keeps coming up year after year that you're not accomplishing? Do any of your
	keeps coming up year after year that you're not accomplishing? Do any of your
	keeps coming up year after year that you're not accomplishing? Do any of your

	Writing a New Chapter Journey: What bad habits do you have that could lead to you making mistakes in any area of your life? Turn to page 144
_	·
-	
	Mending Fences Journey: Do you have unresolved inner conflict that makes you lash or act out at times? Have you thought about talking to someone about this conflict? Research ways you can resolve your inner conflict and write about how you can take steps to start this journey. <i>Turn to page 146</i>

can you take		and other Turn to I			
Spiritual Jor	urney: What does e you ever taken a	s the word "fa leap of faith?	ith" mean to	you? What do	you have
Spiritual Joi faith in? Have	urney: What does	s the word "fa leap of faith?	ith" mean to Turn to page 15	you? What do	you have
Spiritual Jo faith in? Have	urney: What does	s the word "fa leap of faith?	ith" mean to Turn to page 15	you? What do	you have
Spiritual Jo r faith in? Have	urney: What does you ever taken a	s the word "fa leap of faith?	ith" mean to Turn to page 15	you? What do	you have
Spiritual Jo faith in? Have	urney: What does you ever taken a	s the word "fa leap of faith?	ith" mean to Turn to page 13	you? What do	you have
Spiritual Jo faith in? Have	urney: What does you ever taken a	s the word "fa leap of faith?	ith" mean to Turn to page 15	you? What do	you have
Spiritual Jo faith in? Have	urney: What does	s the word "fa leap of faith?	ith" mean to Turn to page 15	you? What do	you have
Spiritual Jo faith in? Have	urney: What does	s the word "fa leap of faith?	ith" mean to Turn to page 15	you? What do	you have
Spiritual Jo faith in? Have	urney: What does	s the word "fa leap of faith?	ith" mean to Turn to page 15	you? What do	you have
Spiritual Jo faith in? Have	urney: What does	s the word "fa leap of faith?	ith" mean to Turn to page 13	you? What do	you have
Spiritual Jo faith in? Have	urney: What does	s the word "fa leap of faith?	ith" mean to Turn to page 15	you? What do	you have
Spiritual Jo faith in? Have	urney: What does	s the word "fa leap of faith?	ith" mean to	you? What do	you have
Spiritual Jo faith in? Have	urney: What does	s the word "fa leap of faith?	ith" mean to	you? What do	you have
Spiritual Jo faith in? Have	urney: What does	s the word "fa leap of faith?	ith" mean to	you? What do	you have
Spiritual Jo faith in? Have	urney: What does	s the word "fa leap of faith?	ith" mean to	you? What do	you have
Spiritual Jo faith in? Have	urney: What does	s the word "fa leap of faith?	ith" mean to	you? What do	you have
Spiritual Jo	urney: What does	s the word "fa leap of faith?	ith" mean to	you? What do	you have
Spiritual Jorfaith in? Have	urney: What does	s the word "fa leap of faith?	ith" mean to	you? What do	you have
Spiritual Jo	urney: What does	s the word "fa leap of faith?	ith" mean to	you? What do	you have

Your Journey Retrospectives

Destination Journey Retrospective

Finding your life's purpose or true calling

1. Do	you feel like your true calling must be something you're passionate about, hing you're good at or something that pays the bills?
	and for the great area of the first state of the fi
2. Wh	at did you learn about yourself through this journaling process?
3. Wh	at does your heart keep telling you?

4. What reservations do you have about pursuing your true calling and why?	
5. What is your dream profession or job? Do you think that is your true calling?	
6. At this point in your life, what do you think your life's purpose is and what led you to this answer? Do you think this decision will change at some point in the future?	

Humanitarian Journey Retrospective

Make a difference in the world

1. When you think about making a difference in the world, what's the first thing that comes to mind and why?
2. Why do you think one person can make a difference?
3. Describe the kind of person you want to be and why you feel it's important to make a difference in the world?

4. What is something new you learned through this journaling adventure that can help you be a better humanitarian?
5. What cause or issue are you most concerned about and how do you plan to help?
6. Do you think it's more important to focus your energy in your own back yard where you live, like your community or in other countries for those less fortunate? Do you think it's more important to raise awareness, money or get hands-on involved and why do you feel this way?

Overcomer's Journey Retrospective

Conquering your fears

	1. What's the most helpful thing you learned while addressing your fears?
-1	
	2. Did you discover anything contributing to your fears you can change quickly or easily?
-	
	3. What's something new you're trying that you hope will help you with your fears?
199	

4. What advice would you give someone who is also trying to conquer their fears?
5. How do you know the fear you have is really fear? What clues led you to know this is something you were really afraid of?
6. Were you able to overcome at least one fear by the end of this journey? If yes, how did you do it and how do you feel now? If no, what do you think it will take and why?

Chaotic Resolve Journey Retrospective

Achieving inner peace

	1. How chaotic was your life at the beginning of this journey and what was causing all the chaos?
	2. What did you learn about yourself that was preventing you from having peace in your life? What is the one thing you changed immediately?
-	
	3. What was the hardest truth you had to face on the journey to achieve peace?

4. What do you love most about the feeling of peacefulness and did you discover something on this journey that gives it to you?	
5. Have you found the peace you're looking for or are you on the road to get there?	
	14
6. Thinking about your life and moving forward, how hard will it be to continue your journey towards peace? Do you think this is something you can achieve, or will it be an ongoing battle? What will be your biggest obstacle?	

Achievement Journey Retrospective

Creating new goals

-	
	1. How realistic were your goals at the start of this journey? Were you challenging yourself enough or setting the bar too low?
	the state of the s
	2. What did you discover about your work ethic as it pertains to your dreams and goals?
	3. Did you make any major life changes through this experience?
-	

4. How did your dreams and goals change through this journaling process? Talk about what changes you made or why you didn't make any.
5. Is anything or anyone still standing in the way of your dreams or goals?
6. Thinking about your future, where do you want to be in the next 5 years, 10 years and then 20 years?

Self-discovery Journey Retrospective

Exploring your true creative passions

1	. What new self-discoveries did you make concerning your creative side?
2 ×	Did you find a spark or connection with a specific passion or hobby you forgol was there or missed due to lack of time? How are you planning on reconnecting
3	3. How deep was your self-reflection during this journey and did it give you a wake-up call in any area of your life?
·	

4. How much creative freedom were you giving yourself in your own life?	
$\bf 5.$ Did you find anything missing from your life? If so what was it and what are you going to do about it?	
	7
6. How do you feel about your life right now and what changes moving forward	
are you planning to make? Does any area of your life feel incomplete, if so how?	
	69

Writing a New Chapter Journey Retrospective

Learning from past mistakes

1.	What was the scariest or hardest thing about facing your mistakes?
-	
2.	How have you changed your thinking as a result of this journey?
3. ×e	Were any relationships impacted through this process? If so, why and howere they impacted?

4. What is the most positive thing you take away from this journaling adventure?	
5. What one thing did you find yourself thinking about over and over while completing these prompts?	
	1 1
6. What do you need to do to complete this new chapter in your life? How does it feel to be working on a new chapter in your life and what will you do different going forward?	

Mending Fences Journey Retrospective

Righting my wrongs

hardest part?		
2. Have you changed t	he way you treat people	around you?
	4 4	
3. What one thing do v	ou feel most remorseful	for and why?
,		

4. Has your opinion of yourself changed during this process, if so how?	
5. What shortcomings did you learn about yourself that you're taking a serious look at now? Have you addressed any of your internal issues?	
6. Are you planning on repairing any damaged relationships moving forward? How will you be different with new people or relationships after this reflective journey? What bad trait are you leaving behind?	

Self-improvement Journey Retrospective

Loving yourself through acceptance

	1. In what ways were you too hard on yourself or not enough loving?
	2. How are you going to be kinder to yourself?
<u> </u>	
da la	
	3. What one thing made you feel the way you did about yourself before? Why did it have such an impact on you?

_		
	4. What good things have you added to your life because of this journey and how has it helped?	
		-
_		
	5. Do you look at yourself differently now after this journey? Do you see yourself better or worse and why?	
	6. Write about the beautiful person you are today. What about your beauty is unique and original? Describe your internal and external beauty in your own words.	
		-

Spiritual Journey Retrospective

Exploring your beliefs

1. What was the hardest thing to understand about your spiritual journey?
2. Was there anything you didn't like about this journey and why?
3. Did you gain anything from this journey, if so what?